SLAVE LABOR
IN THE
CAPITAL

SLAVE LABOR
IN THE
CAPITAL

Building Washington's Iconic
Federal Landmarks

BOB ARNEBECK

THE
History
PRESS

Published by The History Press
Charleston, SC 29403
www.historypress.net

First published 2014

Manufactured in the United States

ISBN 978.1.62619.721.3

Library of Congress Control Number: 2014953171

To Leslie's vegetables

CONTENTS

Acknowledgements

Most of the research for this book was done at the National Archives, Library of Congress and Historical Society of Pennsylvania in the late 1980s for my book *Through a Fiery Trial: Building Washington 1790–1800*. After publication of that general history of the city's founding, which hardly told the story of the slaves and other workers, I still could not keep my hands off those records that told more about what the masons, carpenters, bricklayers, quarriers and slave laborers did. I kept sharing insights from the records on my web pages, and historians like John G. Sharp and Terry Buckalew shared their ongoing work on the Washington Navy Yard and a recently discovered African American graveyard in Philadelphia. Buckalew is uncovering the life of Ignatius Beck, one of the slaves who worked on the Capitol. We all keep the faith that, with patient work, we could focus light on forgotten lives. The work that genealogists have put online has also been invaluable, especially those exploring Charles County, Maryland. Edward Papenfuse has made the Maryland Archives online into a gold mine for anyone looking for nuggets of early history. James Gage, at StoneStructures.org, helped me identify quarry tools. Julia King shared insights on George Hadfield's views on slavery.

Banks Smither of The History Press rescued me from the web and resuscitated an interest in making a book with illustrations. Finding illustrations was not easy. Artists in the 1790s were not inclined to depict working men. Today, museums and historical societies are overly protective of portraits in their collection, so I couldn't fill the book

up with men wearing wigs. To capture some idea of what workers in the 1790s experienced, I had to widen my search. Fortunately, I was not alone. I received help from my wife, Leslie Kuter; James Gage at StoneStructures.org; Jerry McCoy at the Georgetown Public Library; Dawn Bonner at the Mount Vernon Ladies Association; Chris Hodapp, who knows all about Freemasonry; Sara Good at the Mercer Museum in Doylestown, Pennsylvania; and fellow devotee of Washington history Don Hawkins, whom I literally met in the primordial swamp.

Leslie also read chapters and sent me snarling back to make needed revisions. Our son, Ottoleo, saved the day by looking things up in the library. Marlee shared her potato chips and liked what she read. Finally, thanks to airlines never refunding fares despite book deadlines, I learned that there is no better place to research the stones of Washington than in Italy, Switzerland and Austria. Luca, Sarah, Sergio, Victoria and Gaby stimulated the brain as well as the palate. And what should I see in the Kunsthistorisches Museum in Vienna but Bruegel's Tower of Babel with the perfect and timeless detail depicting a laborer attending a mason.

INTRODUCTION

In 1798, a Polish tourist, Julian Niemcewicz, inspected the work on the Capitol. All who saw the large building under construction were impressed, and Niemcewicz was no exception. But his eyewitness account of the construction is exceptional in one respect: only he noticed the hired slaves working on the building. He spent two days walking around the Capitol and jotted down his impressions in his diary. He marveled at the "huge scaffolding" surrounding the building and "200 workers, raising the stones by means of machines and placing the first framework of the roof." He asked to see the architect and was led up to the roof. He didn't describe the workers but noticed that "all were working in silence." Walking around the building, he saw that "for a considerable distance the ground was covered with huge blocks of…stone, some already cut and polished, others yet undressed." There were "sheds" for working and "a shelter for the workers," plus some cabins "scattered here and there" and a few grogshops.

When he came to the site for a second look, he got a different impression. At eleven o'clock in the morning, "no one was at work: they had gone to drink grog." He learned that the workers took two grog breaks a day as well as a break for breakfast and dinner. "All that makes four or five hours of relaxation. One could not work more comfortably." Then he corrected himself. There were men working on the building. "The negroes alone work."

In the eighteenth century, "Negro" was synonymous with "slave." He didn't estimate how many slaves he saw working, only saying he saw them "in large number." At first he was impressed. Someone told him that the

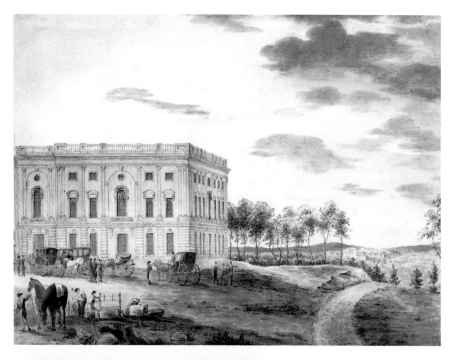

Above: Thomas Birch's drawing of the Capitol in 1800. Only the North Wing was completed. *From the Library of Congress.*

Left: Julian Niemcewicz was the only tourist to write down his impressions of the hired slave laborers. 1822 portrait by Antoni Brodowski. *From Wikimedia Commons.*

slaves "earned eight to ten dollars a week." But he soon learned the truth: "I am told that they were not working for themselves; their masters hire them out and retain all the money for themselves. What humanity! What a country of liberty. If at least they shared the earnings!" And in 1798, those earnings happened to be a little over six dollars a month.

Unfortunately, Niemcewicz told us nothing more about the slaves. He didn't even speculate as to why the slaves who got no pay kept working while the other men, who were paid by the day and not by the hour, loafed. He didn't mention seeing slave overseers with whips.

Like most European tourists who came to the city, he soon moved on to Mount Vernon, where the recently retired president presided over his plantation with over three hundred slaves. The relations between the races were more clear-cut there. The slaves did all the farm and housework while the whites lived graciously. Niemcewicz inspected the fieldwork and slave quarters, which he thought rather shabby. He enjoyed the Washingtons' hospitality.

Eyewitness accounts are usually the stuff of history. Niemcewicz's report on Mount Vernon is one of the best we have. In 1798, it was easier for a tourist to focus on the ordered world of plantations like Mount Vernon than on the chaotic arrangement on and around Capitol Hill. Not only were stones strewn about the Capitol but around the hill, houses, the building blocks of a city, seemed strewn about in a haphazard fashion. Niemcewicz described the city as he viewed it from the unfinished roof of the Capitol: "The great avenues cut into the forest of verdant oak, indicated the spaces destined for streets, but today...one sees nothing and hears there only the silence of the trees."

In 1797, a French visitor interested in real estate speculation counted all the houses in what was called the city of Washington. The distances were daunting. Streets had been cleared, blocks surveyed and public squares for government buildings and public parks marked in an area extending the four miles from Rock Creek to the Anacostia River and roughly over a mile north of the Potomac River, about as large an area as London, which then had a population of around three hundred thousand.

By the Frenchman's count, the city of Washington had 322 houses, and only 155 were occupied. There were 17 houses in the vicinity of the unfinished White House and only 8 around the Capitol. Add to that, none of the streets were paved or cobbled or, for that matter, much used save for the cart paths the slaves used as they took stone and lumber up from the two public wharves to the White House and Capitol. Turn another direction from them and you could see fields of wheat and corn still being worked by

the slaves of well-to-do families who had done their mite to convince the federal government to build the nation's capital on the Potomac River.

The reality of the city-to-be and insanity of its promoters perplexed eyewitnesses. Many in the city thought they would soon be millionaires, including the man guiding Niemcewicz around the city. The Englishman Thomas Law made a fortune in India and was investing it in the city of Washington. To landowners and speculators, the city seemed to be developing at breakneck speed.

In 1787, Article I Section 8 of the Constitution gave Congress the power to designate a federal district under its control not larger than ten miles square.

In 1790, Congress passed the Residence Act authorizing the president to place the district along the Potomac, provided the principal public buildings were in Maryland; Congress also mandated that the federal government would move from Philadelphia to the new capital in 1800. That Maryland and Virginia offered seed money, $72,000 and $120,000, respectively, helped seal the deal.

In January 1791, the president chose the site of the district encompassing Georgetown, Maryland, and Alexandria, Virginia, and he appointed three commissioners to supervise surveying the district and build a city within it.

In March 1791, the president announced the boundaries of the federal city and approved a scheme to divide all the land in the city with its owners with the understanding that the government would survey all the land not used for public purposes into over 1,200 squares formed by streets and avenues and divide them into building lots. The government would periodically auction some of the lots it owned to raise money to build government offices and develop the city's infrastructure, including a major deepwater port and a canal. At the same time, private owners could develop and sell their lots and become millionaires.

In August 1791, the president tentatively approved a plan for the city. In October 1791, the commissioners held the first auction of public lots.

Of course, the president was George Washington. In September 1791, the commissioners named the city after him. He was, after all, the most famous living man in the world.

Then the real work began. Many of the workers embraced the enthusiasm. They had come to America from Ireland, Scotland and England and flocked to the city to build their futures as well as a capital city. Of course, they were free men, free to come and go, but many bought building lots in the city and embraced the dream, perhaps as they drank grog during their breaks.

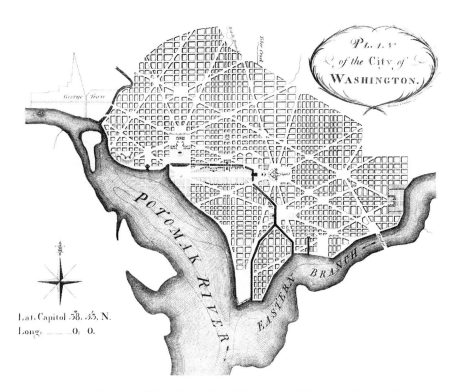

An engraving of L'Enfant's "Plan of the City of Washington." *From the Library of Congress.*

As for the slaves first hired by the commissioners in April 1792, we can't say the slaves didn't have dreams, but they certainly weren't encouraged to have them. Many came from faraway plantations to which they were expected to return when their work was no longer needed.

Not much was written about them. Not much was expected of them. They were another man's or woman's property.

Fortunately for historians trying to describe how the Capitol and White House were built, the three commissioners appointed by President Washington to oversee the project generated a considerable paper trail. After 1794, almost everything was accounted for, down to the "X" the slaves made on a payroll on the occasions they were personally paid thirteen cents a day for their labor. By the way, most historians of the city's founding noted the presence of hired slaves. Their role was never made a secret.

"X" is a symbol of the unknown, but the hired slaves are not unknown. Each slave's first name was generally coupled with the last name of their master. Accounts were kept of when and where they worked and of what

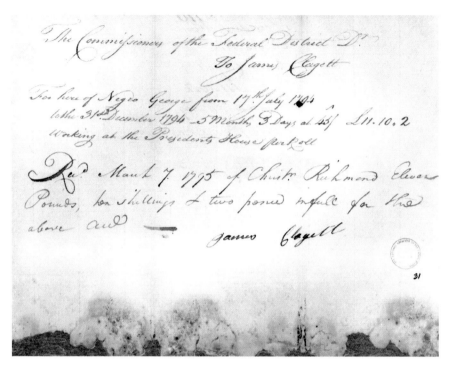

This receipt shows that Thomas Clagett made $30.59 for six months of work by his slave George. *From the National Archives.*

they were fed and what medicines they got. We can dig into that and try to piece together where they came from and where they worked.

We can only get a general idea of what they did. The hired slaves were often simply listed as laborers working at the Capitol or president's house. Of course, the latter was not called the White House until well after it was built. As it was being built, it was often called "the Palace." Since the rented house in Philadelphia where the president lived and worked from 1791 to 1800 is now called the president's house, in this book we'll call the building the president moved to in 1800 the White House.

What was called the Capitol was only briefly called the "Congress house." No one could resist associating the American Republic with the Capitoline Hills of the ancient Roman Republic, which, by the way, was no stranger to slavery. In this book, the Capitol referred to was much different than what we see today. Between 1793 and 1800, slaves only helped build the North Wing of the original design. That design was trumped in the 1850s when new Senate and House wings were built that were several times larger than

the original wings that were finished in 1800 and 1807, respectively. The first Rotunda in the middle wasn't finished until 1826, and what we see today was finished during Lincoln's administration.

Actually, the White House that President Adams moved into in 1800 had a front that was fifty feet longer than the North Wing of the Capitol that the Senate and House met in. Not for nothing were people in 1800 continuing to call the huge building on the west end of Pennsylvania Avenue the Palace.

Both buildings were built at the same time, though the White House had a year's head start. So it doesn't make sense to tell the hired slaves' story based on what they did at each building. As you might imagine, the first step was to clear the land and connect the work sites with some roads. Because the sale of building lots to private citizens was deemed essential to financing the construction of the public buildings, there was a high priority on clearing as many of the planned avenues and streets of the new city as possible.

So the hired slaves first made their mark as axe men.

If the nation's capital had been built near a large city, there would have been an established supply of building materials. But Georgetown, Maryland, and Alexandria, Virginia, were not quite big enough (2,315 and 2,748 people, respectively) to offer stone, lumber and brick yards.

So describing the slaves' work as it related to stone, lumber and bricks makes sense. They had to quarry, cut and bake those materials. Then they had to haul all of it with only sails, horses and oxen to help. The payrolls of the skilled workers in the commissioners' records are divided into those for surveyors, stonecutters, stonemasons, stone carvers, sawyers, carpenters and bricklayers. The hired slaves played a role helping or working in each craft.

The slaves' hands on axes, stone, wood and brick sounds like a logical way to organize a book, save that hiring slaves to help build symbols of freedom doesn't seem logical at all. Unfortunately, that contradiction didn't strike any of the men and women building the new city. There was no debate about the use of slaves.

However, in this book, to get at what happened, we best not lecture and impose moral strictures on those who organized the hiring of the slaves and those who worked them and worked with them. We do that out of respect for the slaves.

The society they lived in conspired to deny them a voice not only in the decisions that affected their lives but also in ways to express their humanity. We have no letters from the hired slaves. Those who were asked to sign their names only marked an "X." Filling that silence by bragging on their skills or insisting on what their dreams must have been drowns out the only chance

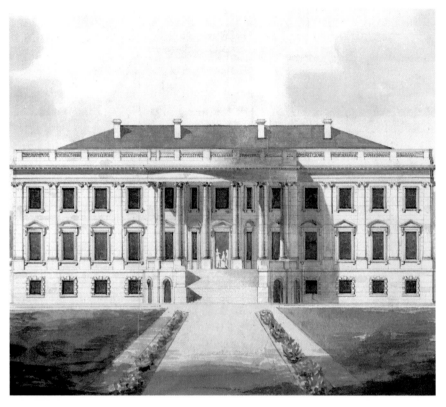

Benjamin Latrobe's 1817 drawing of the south front of the White House cropped to show the portion built by 1800. *From the Library of Congress.*

we might have to pierce that silence. This book looks at the work they did and how they were forced to live.

Compared to Niemcewicz's observations in 1798, the next reaction to their work was somewhat cruel given all that we will learn in this book about what they did. After 1798, most of the slaves were sent back to their plantations and not hired back. There was plenty of work left to be done, but the commissioners thought they had run out of money.

In November 1800, First Lady Abigail Adams stood at the window of the White House and saw a small gang of slaves clearing dirt and rubbish from her yard. In a November 28 letter to a friend back in Massachusetts, she opined dismissively:

> *I have amused myself from day to day in looking at the labor of 12 negroes*
> *from my window who are employed with four small Horse carts to remove*

some dirt in front of the house; the four carts are all loaded at the same time and whilst four carry this rubbish about half a mile, the remaining eight rest upon their shovels; two of our hardy N. England men would do as much work in a day as the whole 12.

Born and bred in Massachusetts, the first state to abolish slavery, she rightly blamed the overseer for the inefficiency. But she seemed to have no sense of how the slaves had handled all the stone, bricks and wood that surrounded her, nor of how closely slaves had worked with the skilled men who set and nailed together the largest building in America. She didn't seem to grasp that the three commissioners overseeing the building who hired both the slaves and overseer served solely at the pleasure of her husband the president.

Admittedly, it would have been a long story to tell her, and it remains a hard story to tell. But by using the archival records, we can try to describe their world. We just won't be able to know what they thought and can only speculate on how they suffered and survived. We begin by asking from where they came.

1

FAR FROM HOME

No one ever described the arrival of any of the slaves hired to build the Capitol and White House. Getting slaves to those work sites would hardly seem to be an issue. In 1790, there were more slaves in Prince George's County, Maryland, than whites: 11,176 to 10,004. That was the county from which the city of Washington was extracted in 1800 when the federal government officially made it the national capital. It is often assumed that all the slaves needed, never more than 100 in the peak years of slave hire, lived nearby. Indeed, around 400 slaves lived a few miles from the site of the Capitol. Over 600 lived in Georgetown, not far from the site of the White House.

But to accurately imagine the arrival of the slaves contracted to work in the city for a year, we have to picture the first preparations for the move taking place on a wharf in the Patuxent River just below a plantation called Resurrection Manor. The master there, Edmund Plowden, could not simply give passes to the eight slaves he hired out—Gerard, Tony, Jack, Moses, Lin, Arnold and two slaves named Jim—and expect them to walk. St. Mary's County, Maryland, is not within walking distance of Washington.

Plowden could have sent his slaves by wagon, but given the nautical bent of Marylanders who lived on the creeks and rivers convenient to Chesapeake Bay, he more likely sent them on a sloop with two sails. Remember, no one ever described this, and if we are left to imagine it, we might as well make the sloop's voyage a memorable one and imagine that it picked up every hired slave along the way as it sailed southeast toward the bay, rounded Point Lookout and hoped for a south wind to push it up the Potomac River.

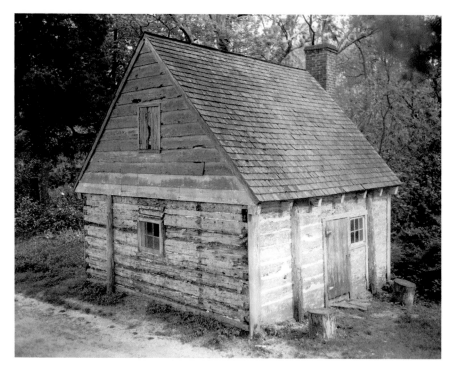

Old log slave cabin, St. Mary's County, Maryland. *From the Library of Congress.*

Its next stop might be St. Mary's City on the other side of the peninsula that forms St. Mary's County. We are not sure if E.J. Millard lived there, but he was a lawyer and county official, and that city is still the county seat. So welcome his slaves Tom and Joe aboard. St. Mary's City is ninety nautical miles from the city of Washington, but our imaginary sloop had to deviate from a true route. The innumerable bays along the river had eased access to tobacco plantations for the past 150 years, and that's where slaves who could be spared for work in the city lived.

The Wicomico River forms the border between St. Mary's and Charles Counties, and the sloop had to put in there to pick up Bennett Barber's four slaves. A Luke Barber and Ann Barber also hired out slaves to the city. Then our sloop might have to wait for the Reintzell slaves to come down Chaptico Creek—Valentine Reintzell's Mike and George, as well as his brother Anthony's slaves Dick, Jacob, Will, Amos and Charles. The sloop's major port of call was Port Tobacco in Charles County, about forty-two nautical miles from the city of Washington. There we picked up Tom, Jack and Dick, who were hired out by Miss Anne Digges. The five daughters of

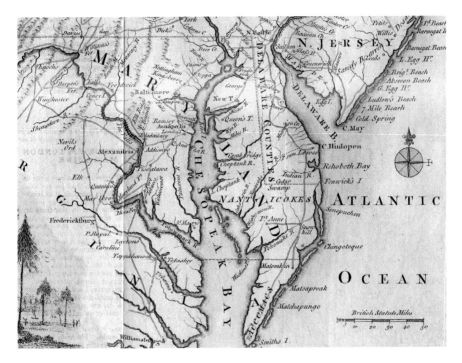

This map by T. Kitchin printed in the *London Magazine* in 1757 shows the extensive shorelines of Maryland along the Chesapeake Bay and Potomac River that supported slave plantations. *From Wikimedia Commons.*

the late Robert Brent of Charles County—Mary, Elinor, Teresa, Elizabeth and Jane—each hired out a slave or two to work at the Capitol: David, Charles, Silvester, Gabe, Henry and Nace. Assuming they didn't inherit large farms too, here was a way to profit off their inheritance rather than selling their slaves. Then there were Joseph Queen's slaves: Anthony, Moses, Joseph, Walter and Tom.

The Potomac narrows as it snakes between Charles County, Maryland, and Stafford County, Virginia. There were as many Brents living in Virginia as there were in Maryland and many Brent slaves in each state. But the notion was widespread that if a Virginia master hired out a slave for work in Maryland, or vice versa, for over a year, that slave might be able to sue for his freedom. So our imaginary sloop made its stops along the Maryland shore, though as we'll see the commissioners hired slaves to cut timber in Westmoreland County, Virginia, and quarry sandstone in Stafford County.

At Piscataway Creek, which forms a wide bay, our sloop finally reached Prince George's County. The road from Nottingham fifteen miles away came

down to the creek. Although also on the Patuxent River, that village was about twenty-five miles from the site of the Capitol, so Robert Young's slave Abraham and Ignatius Boone's slaves Charles, Moses and Jacob might still be sent up in our sloop. A few more slaves belonging to members of the Digges family could have been picked up at Fort Washington, but most of the Prince George's County slaves probably walked to the city. The same can be said for the Montgomery County slaves. Georgetown would become part of the District of Columbia but until 1800 was a part of Montgomery County.

So our imaginary sloop picked up at least thirty-eight slaves. In reality, they all probably never worked in the city at the same time. But judging from the records we have, the slaves of Edmund Plowden and Joseph Queen worked in the city from 1794 to 1799 and likely began working there in 1792. Indeed, many of the local slaves, those within walking distance, were hired by the month, not the year. Most of the slaves on our imaginary sloop were hired out in January and worked until December. (Another reason making our imaginary sloop's voyage unlikely is that, in those days, ice could stop boat traffic on the Potomac in the winter.)

The St. Mary's and Charles County slaves likely appreciated meeting those Georgetown slaves like Jack and Peter, who were owned by Middleton Belt, or Dick, Oliver and George, who were owned by Mary Magruder. Belt hauled building materials for the commissioners. Magruder was probably a member of the Georgetown family that sold Indian meal to the commissioners. City slaves owned by them probably knew what was going on at the work sites and might explain some strange things to the St. Mary's slaves.

For example, they did the same jobs as a handful of free blacks. We know of them because they were listed on payrolls as "Negro Caesar Free" or "Free Isaac." We learned of Isaac's full name because in the next payroll, there is an Isaac Butler. Just below that name is a Rhody Butler, so he was likely a free black too.

We learned about a free black laborer named Jerry Holland because he was an excellent worker. In January 1795, an assistant surveyor attached a note to the December payroll: "Pay Jerry the black man at the rate of $8 per month, for his last months services, he is justly entitled to the highest wages that is due to our hands—being promised it and the best hand in the department—Dorsey excepted." If it wasn't for that letter, we might still think Holland was a free white laborer. (Holland continued to work for the commissioners until 1800, acting as their servant and living in a small stone house next to their office. They bought him a great coat for $7.50 to keep him warm in the winter, but he never got paid more than the hired slaves.)

The number of free white men who did the same work as the hired slaves was probably most surprising to slaves from the tobacco plantations. The commissioners annually passed resolutions calling for "Negro laborers," but usually the ads in the newspapers just said "laborers." White men signed up and worked for the same low wages. The records we have suggest that the white laborers did the same jobs as the slave laborers, and both often worked side by side with the skilled white workers. But at least the white laborers got to keep the wages they earned.

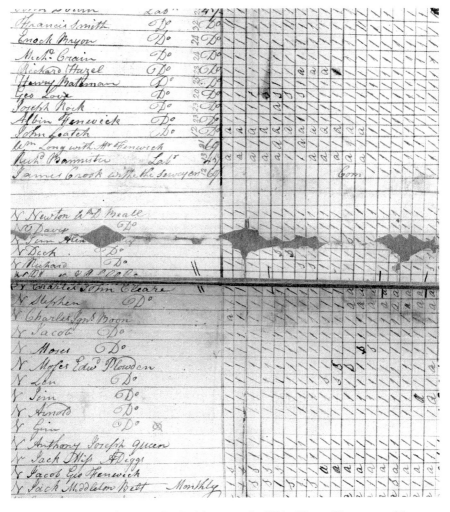

Detail from photo of time sheet for the laborers at the White House. The names of free workers are listed on the top, and slaves are marked with an N listed on the bottom. *From the National Archives.*

Slaves and freemen working together was not a novelty in eighteenth-century cities, even in the South. Racial lines had not hardened then as much as they would in the nineteenth century. Around the Capitol and White House, there was generally one white laborer for every three slave laborers. In the summer, the best time for building, the number of white laborers hired by the month swelled and might outnumber the hired slaves.

Overseers began keeping payrolls and time sheets for the laborers in late 1794. On the time sheet for December, the overseer Bennett Mudd, probably himself from Charles County, tops the list, followed by the cook Thomas Smith; two men who handled the scow used to deliver sandstone come next, and then the laborers are listed last. Thirteen freemen, with John Doran first, and twenty-six slaves are at the bottom, with "N Newton—Beall." That means Newton was Beall's slave, as was N Davy, the next man on the list. From other records, we know that Newton and Davy's master was William D. Beall.

Likely many of the slaves had both a first and last name, but only one hired slave was ever listed with both names in the commissioners' records. There is this short note in the records dated December 2, 1795: "pay to Barton Ennis for use of Catherine Green negro hire." There is nothing else known about her or her master. She was likely the only female slave hired by the commissioners.

We might latch on to the division in the payrolls between slave and white workers to suggest that they were segregated and that the slaves worked under more severe conditions. Indeed, on July 30, 1794, the commissioners directed the man overseeing their overseers "to keep the yearly hirelings at work from sunrise to sunset particularly the negroes." Severe as that may sound, the order didn't allow the whites to quit early, and as we shall see in the chapters examining the work the slaves did, free and slave laborers did the same jobs. In later payrolls, the slave and free laborers are mixed together.

All the hired laborers were guaranteed a place to sleep. Does that mean white and black laborers slept in the same quarters?

Given the number of laborers guaranteed a place to sleep by the commissioners, one would think there would be descriptions of where the slaves lived. However, no one left any, and in the commissioners' records, there are only two mentions suggesting where the hired slaves slept.

In December 1794, a contractor was paid to haul five logs to the "laborers' camp on Capitol Hill." In 1800, after slave hire ended, a man was paid to haul the "camps" off Capitol Hill, and it took his crew and wagon two days to do it.

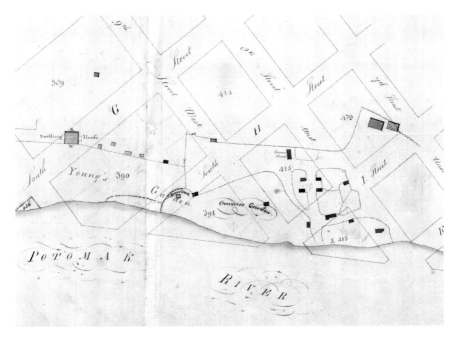

A 1796 Nicholas King map of Notley Young's manor house showing nearby gardens and slave cabins. *From the Library of Congress.*

Skilled white workers lived in temporary housing or huts that were built on the Capitol and President's Squares, often four to a room, or in barracks, one made of bricks, two stories, with enough small rooms to board thirty-two workers, two to a room with four men sharing one chimney. The laborers' camp must have been even less accommodating.

The slaves in the nearby Notley Young plantation lived in log cabins strung out on a ridge overlooking the Potomac. There were garden plots between cabins. That must have seemed like paradise to any hired slaves who saw it. Their camp was probably in the most inconspicuous corner of a public square and without any gardens. Who would tend them? The hired slaves couldn't bring their families.

There is no reason to assume that the races were segregated. The white laborers ate the same food, had the same overseers and went to the same hospital when they were sick. In December 1797, the commissioners paid Thomas Dixon wages for being a laborer and paid him the wages of his slave Will "at same rate" but deducted three dollars because the commissioners had paid a doctor that amount for inoculating Will against smallpox. White laborers who were immigrants would not have found living with blacks

unfamiliar. In tenements and alleys near the wharves of Philadelphia and New York, immigrants and recently freed slaves lived together.

Plantation owners like George Washington were careful to keep slaves from sleeping next to white overseers or hired free workers who had drinking problems. Drunkenness became a problem among workers in the city of Washington, almost all of them single men or without their wives, just like the hired slaves. But keeping hired slaves away from the white workers would have required making a camp far from their work sites because, as Niemcewicz pointed out, that's where the grogshops were.

We'll examine the living conditions of the laborers in a later chapter. For now, let's go back to our imaginary sloop, which raised more questions than it answered. Its journey up the Potomac showed us where many of the slaves came from, but it did not really tell us why so many slaves came from so far away.

The letters of the commissioners are mum when it comes to slave hire. This all happened well before the era when governments constantly studied themselves to make the bureaucracy more efficient. There was hardly any bureaucracy: three commissioners told one man to hire slaves. So in their records, there is not even a hint at why almost a third of the slaves hired came from such a distance.

Here's a guess: Miss Digges was a member of a prominent Maryland family that was intermarried with the family of Daniel Carroll of Rock Creek, one of the three commissioners hiring slaves. His sister-in-law had married one of the Fenwicks, who were related to the Plowdens. The Brents had intermarried with the Fenwicks, Plowdens, Diggeses and Carrolls. They were all prominent Maryland Catholics who all trusted Daniel Carroll, whose brother was Bishop John Carroll of Baltimore.

Slave hire allowed a network of slave owners well known by Commissioner Carroll to profit at little cost to them. Although there was no public comment about the financial aspects of slave hire, no pamphlets explaining or extolling the practice, masters grew very comfortable with it. All they needed were some rudimentary skills in math to understand its virtues.

On January 5, 1796, Samuel Davidson, a Georgetown merchant who owned the land just north of the White House and who personally owned just one slave servant, sold Negro Thomas to a newly appointed commissioner, Gustavus Scott, for 112 pounds, 10 shillings.

Let's take a brief digression and explain the money used in Maryland in the 1790s. The new federal government established a mint in Philadelphia and, by 1795, wanted all states to calculate value using the dollar system we have today. But pounds, shillings and pence were used also until 1800.

Twelve pence equaled one shilling, and twenty shillings equaled a pound. In an economy where there were not many coins, it was a convenient way to keep track of things. In Maryland, the exchange rate between the two systems was one pound equaled $2.66. It makes sense to count money the way people using it did and then put the punch line, as it were, with a dollar sign.

Davidson had bought the slave a week before from a Charles County merchant for eighty pounds. Davidson bought clothes for the slave, at two pounds, nineteen shillings and five pence, and sundries at three pound and two pence, and calculated his profit at twenty-six pounds, ten shillings and five pence or about seventy dollars.

Slave hire gave masters who did not have work for a slave to do an option to profit from him without having to sell him. The commissioners hired a slave worth about one hundred pounds for twenty-one pounds a year. The slave's master would not have to feed the slave, and the value of the slave, as long as he didn't get injured or run away, would not decrease. The master was making roughly a 20 percent return on his or her "investment," and that was in an era when some thought making over 6 percent was sinful.

Then there is the case of Joseph Beck, who had a small farm out near what would become Bowie, Maryland, in Prince George's County. The land and slaves his father bequeathed to his children was evenly divided, and as historian Terry Buckalew discovered, one of the slaves had to be freed when he reached the age of twenty-five. Beck's farm was too small to make a profit, so he hired out his slave Ignatius since the sale value of a slave soon to be free was not very high.

Slave hire was so attractive that several of the men in charge of various aspects of the work in the city, including two commissioners, hired out their own slaves to the commissioners. Commissioner Scott hired out Bob and Kit, but if you weren't a commissioner, that could be risky.

Samuel Smallwood, the overseer of slaves at the Capitol, began hiring out his own slaves by the month to work at the Capitol. In September 1797, in order to economize, the commissioners stopped monthly hires. Smallwood complained to the commissioners, "If I can't prevail on you Gentlemen to take them in again, It will Certainly take my own Wages to Support them this winter as they are not one Days work to be had." He was stuck feeding his slaves without getting any money from their work. Smallwood lived in a small house on Capitol Hill, not a large plantation where there was always something for a slave to do.

Middlemen soon got involved in the slave hire process. In November 1794, a month before slave hire contracts were finalized at the first of the new year,

This detail of a payroll shows Samuel Smallwood collecting the monthly wages of the four slaves owned by a man named Parker. *From the National Archives.*

John Slye offered to bring thirty "valuable Negro men slaves" owned by friends on the condition that they would get sixty dollars a year for each slave and the commissioners would hire Slye as an overseer. The commissioners hired Slye, who, by the way, had family roots in St. Mary's County.

Since the records show Samuel Smallwood signing for the receipt of wages of the hire of several slaves whom he didn't own, it is likely he also acted as an agent for other masters. Dr. James Blake did the same thing, as well as hiring out his own William, Joseph and James. He seemed to specialize in acting as the agent for those few masters who lived in Virginia. Both men were destined to become future mayors of Washington. Blake was appointed by President James Madison, and Smallwood was the city's first elected mayor.

Men who could handle slaves were esteemed by the citizens of Washington, from the president to the average white male voter.

While the financial aspects of slave hire make sense to us today, that the commissioners only hired slaves as laborers doesn't. Why didn't they hire slaves known to be skilled carpenters or masons?

The plantations of the South were in some respects self-contained communities. The fields and pastures provided food and clothing. The woods and earth provided building materials. Most large plantations had slaves with skills in the building trades like carpentry and bricklaying, skills needed by the commissioners.

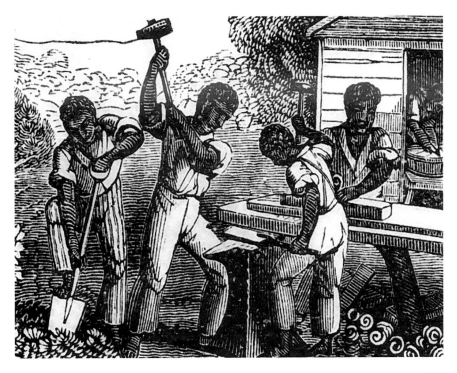

An illustration from the *Anti-Slavery Almanac* shows slaves exhibiting skills. Masters boasted of their skilled slaves but didn't hire them out to the commissioners. *From the Library of Congress.*

In cities like Georgetown and Alexandria, slaves who were not servants often had a trade so masters without crops to tend could still make money off them. Slave owners often noted the skills of their slaves who had run away or slaves they hoped to sell.

A 1797 ad in Georgetown offered a two-dollar reward for twenty-three-year-old Stephen, who was "a painter by trade." In 1799, an ad offered twenty dollars for the return of Charles, "an excellent house carpenter" working in the city of Washington.

It would seem to make sense for the commissioners to try to hire slaves with skills they needed. As we shall see, they did sometimes tailor an ad, asking for slaves to work in the sawpit or quarries, but in general, they only asked for "laborers." They wanted to get hands at the lowest wages, not negotiate with owners over the value of their slaves' skills.

The commissioners made that clear in December 1792. They bought a tract of woods called White Oak Swamp in Westmoreland County, Virginia, convenient to the Potomac so timber could be rafted up to the site of the

White House. Their agent in the matter was William Augustine Washington, the president's nephew. Young Washington found a man to oversee the operation and was advised by him to hire "twelve good Negro carpenters and ten Axe men." Washington urged the commissioners to close the deal before Christmas, "as a Number of Negroes are generally hired out in this Neighborhood on New Year's day, after which time it will be difficult to procure them."

The commissioners wanted timber "felled immediately," but they didn't want to hire any slave "carpenters." At the same time, they were hiring free white carpenters to work on the White House. They had to be paid what carpenters were accustomed to getting, which was just over three times what the commissioners paid for slaves. Paying that much money to a master for a year's labor of a slave reputed to have skills was risky. Free workers could be fired on the spot, but not hired slaves.

The commissioners got periodic lessons in how expensive a skilled slave could be. James Clagett, a local contractor, hired his slave George to the commissioners for five dollars a month. But when the commissioners needed one of their scows repaired, Clagett sent them a crew of four men including "Negro Aaron" and "Negro Davy." They got paid as much as free white carpenters for the four-day job.

Young Washington eventually got all the men he needed, but all were hired and paid as laborers. The commissioners tried to make it policy that any "Negro" got the lowest wage. They deemed a slave only a laborer and

James Clagett charged the commissioners a high wage, $1.40 a day, for his two slave carpenters who repaired a scow. *From the National Archives.*

easily replaced by another slave. In October 1796, E.J. Millard, that St. Mary's County lawyer, tried to take his slaves Tom and Joe away from the White House, and the commissioners said he could do so only if he provided "substitutes," since "the public works might suffer by taking away any of the laborers at this season very materially."

But we shouldn't assume that every slave had a skill. The world of slavery in Maryland wasn't as ordered as some timelines suggest. For example, two sons of the Earl of Albion, Edmund and George Plowden, came to St. Mary's County in 1684 with enough funds to buy tobacco lands and the slaves to work it. That suggests that in 1792, the ancestors of the hired slaves might have been in the country well over one hundred years, ample time to develop skills that are so often passed down from fathers and mothers to their sons and daughters.

But judging from the memoirs of one of the Jesuit teachers at Georgetown College, slaves in St. Mary's County were still close to the bitterness and anger born from their middle passage from Africa. The Jesuit order in Maryland owned six plantations that were worked by slaves in that county. Brother Joseph Mobberly spent some of his early years overseeing operations at one. In his 1823 memoir, he wrote that "about 35 years ago [1788], the negroes in Maryland were chiefly Africans, or those who were immediately descended from them." Mobberly was fearful of Africans who "were skilled in the art of poisoning, and were malicious to a high degree."

That description reflects nothing that happened among the slaves hired to work on the Capitol and White House. There were no murders. Guards were not placed around the laborers' camp. The expressed fear of Africans in southern Maryland in the 1790s does suggest that when a white confronted a slave, the white did not naturally ask, "What can you do?" The whites looked for hard labor to tame the black men they feared. An affirmative action plan for their mutual benefit was the last thing on a white man's mind.

This is not to say that whites were uncomfortable with slavery. Along the Potomac River in the 1790s, no one had to defend slavery because no one was attacking it. Quakers meeting in Philadelphia petitioned Congress, which was then meeting in Philadelphia, to abolish slavery. But no notice was taken of slaves hired by the commissioners, and no pressure was ever put on the commissioners to improve the conditions of their hired slaves beyond their contractual obligation to their masters to feed them, give them a place to sleep and provide medical care if they were sick or injured.

Judging from the commissioners' records, only one man who played a role in the development of the city seemed to have empathy for slaves. John

Templeman recognized the suffering of slaves taken from familiar surroundings for a year. He came to Georgetown from Boston in 1792 and, like several other Bostonians, bought lots in the city. Genealogical records of him are sketchy, but those that are available suggest that he was born in England.

There are the typical vague family remembrances of the basement of his Georgetown house having shackles for his slaves. He did buy slaves when he permanently moved to Georgetown in 1795, but it was not to sell them like Samuel Davidson. He also bought lots on the Washington side of Rock Creek and built a wharf for a shipping business. He was near the wharf and warehouse of Tobias Lear, once President Washington's private secretary, who planned to ship goods to the world. Templeman knew the needs of the commissioners and other builders and scouted the forests of the upper and lower Potomac. He soon recognized the talents of slaves for cutting, squaring and sawing timber into lumber and also for handling the ships, barges and rafts to get the lumber up or down the river to his Rock Creek wharf. In 1801, while rafting lumber down the Little Falls of the Potomac when the river was high from melting snow, some of Templeman's slaves drowned. The local newspaper reported the tragedy as if it was proud of

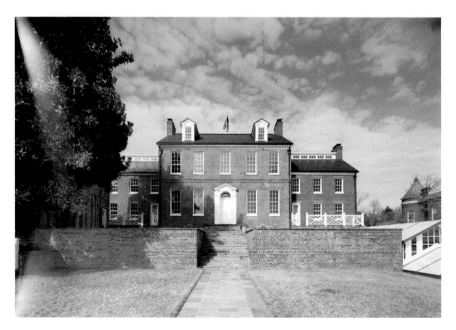

A shipping business employing slaves made John Templeman wealthy. His Prospect House in Georgetown remains one of its finest. *From the Library of Congress.*

their heroics, describing the victims as "a few stout and valuable negro men" and lamenting the "melancholy event."

In 1797, Templeman was one of the directors of the newly organized Georgetown Bridge Company, and he negotiated a contract to hire slaves for the project. Using the slave dealer Edward Burrows as the middleman, he contracted with a Charles County master for the yearly hire of seven slaves on the same conditions the commissioners hired their slaves save for one difference. A clause in the contract allowed "Bob two and a half days four times in the year to go see his wife."

The slaves seemed to know that Templeman was on their side. In September 1799, after Templeman hired six slave sawyers from the commissioners, a sawyer not taken, probably Moses, one of Plowden's slaves, found Templeman and begged to be hired. Templeman promptly wrote a letter to the commissioners and told Moses to take it to them. With a bit of condescension, Templeman asked the commissioners to hire out Moses, too.

Gentlemen. the Bearer, one of your sawyers, has been frequently with me begging that I would write and request the favor of your board, to let him go with the other men who you hired to me yesterday. He assures me that there is a pair of sawyers now at the Capitol, say George and Oliver, who are good and do not want to go below—I hope you will not consider me as Troublesome, I write as much to oblige the Poor Fellow as myself. He seems very uneasy at being obliged to stay, where the others are gone to work very near home.

The commissioners agreed, and Moses shipped out with the other slaves, two belonging to the Brent sisters and four to Joseph Queen.

There is no evidence that Templeman's sensitivity to a hired slave's wanting to see his wife back home became an example to others. The commissioners allowed no home leave except that if a slave left the laborers' camp, there was no hue and cry. The slave was simply marked absent, and if he was absent over a week, the commissioners docked the sixty dollars a year pay that they sent to his master.

We can only speculate what effect the slave hire system had on the slaves. But one measure of their reaction to their predicament can be gauged by the lack of newspaper ads about slaves who ran away from the public works. There is only one ad offering a reward for a slave who ran away from the Capitol.

John Mitchell placed an ad offering a six-dollar reward for a twenty-three-year-old slave who "absconded from his employment in the Federal City" on

September 3, 1793. Mitchell described Jacob as "23 years old 5 foot 8 yellow complexion with a bushy head of hair, has a cast in his walk from his thigh being broken—gone to Virginia where his mother lives, made the attempt in April $6 reward."

There is no record of what became of Jacob. Mitchell was a merchant who later sold pork to and made bricks for the commissioners, offering "negroes, horses and cattle" as security.

There are more ads for runaways looking for men suspected of going to Washington. An ad placed by a southern Virginia planter alerted readers to a John who passed himself off as one who "had hired his time for the year and was going to the federal city for employment." Clem and Will from Prince George's County "were last seen on their way to the City of Washington with their broad axes and some other tools."

There is no evidence that John, Clem and Will made it to the city or hired themselves out, which would have been illegal at the time but probably not impossible to arrange. But clearly the fact that slaves were hired to work in the city was widely known by slaves in the region, and perhaps for some, it was an attractive prospect.

Of course, free workers were free to come to the city that, judging from descriptions of it in the newspapers, was going to be the New Jerusalem with plenty of work to do. When John, Clem and Will set off for Washington, they were breaking the law and, if caught, were put in jail by the sheriff. So why couldn't the commissioners manage all the work they needed done with free workers? Exactly why did they hire slaves?

CHOCOLATE BUTTER FOR BREAKFAST

The thirty or so slaves hired by the commissioners in April 1792 replaced seventy-five free workers who were fired in January 1792. If a hired slave asked why those free workers were fired, he probably heard jokes about chocolate, perhaps from their first overseer, a garrulous red-faced Irishman named James Dermott who was not ashamed of his love of drink.

In 1792, the head surveyor, Andrew Ellicott, gained a reputation for making excuses for his not getting streets surveyed and opened. Dermott, who had been a math teacher in Alexandria, Virginia, became a rival who eventually got Ellicott fired and took over as surveyor. In a newspaper war between the two, an anonymous writer (probably Dermott himself) mocked Ellicott for blaming delays on new hands who were "not able to work because they were not well fed, and had no Chocolate."

He was referring to "2 ounces of chocolate butter" that Major P.C. L'Enfant insisted be a part of the breakfast rations of all his workers. After approving L'Enfant's plan for the city in August 1791, the president asked L'Enfant to develop it, and he soon had seventy-five workers acquiring a taste for chocolate butter.

There is no record of chocolate butter being in the rations of any American soldier, seaman or worker forced to live on rations because they worked in remote situations. Certainly, L'Enfant didn't get it after he volunteered for service in the American army in 1777. However, Pierre Charles L'Enfant was born and raised in Versailles, France, where his father was a court painter for King Louis XV. Chocolate was the rage in France at that time. The king had his own recipe for a chocolate drink.

Major P.C. L'Enfant inspired his workers with military ardor that alarmed the commissioners. Sketch by an unknown artist. *From the Library of Congress.*

The first chocolate manufacturer was in Paris, where young L'Enfant went to art school. But most sources suggest that chocolate was extolled then as an aphrodisiac, not as fare for workers. Along the way from Paris to the Potomac, L'Enfant didn't forget chocolate. Evidently, L'Enfant thought it would help his men love their work. Indeed, they were highly motivated, but that treat became a symbol of the extravagance that led to L'Enfant's downfall.

He did not give the treat to hired slaves. That was not the scandal. He didn't hire any slaves. That had nothing to do with his not having any experience with slavery. During the war, after rising in rank in Washington's engineering corps, L'Enfant went to Charleston, South Carolina, hoping to lead one of the regiments of slaves that his friend Colonel John Laurens hoped to organize. If the slaves fought, they would gain their freedom at war's end. Nothing came of the idea.

At the siege of Savannah, L'Enfant led five men on a long-remembered but vain effort to shield an American advance by

King Louis XV of France made chocolate fashionable, fueling a craze for chocolate as L'Enfant grew up in France. Portrait by Francois-Hubert Druais. *From Wikimedia Commons.*

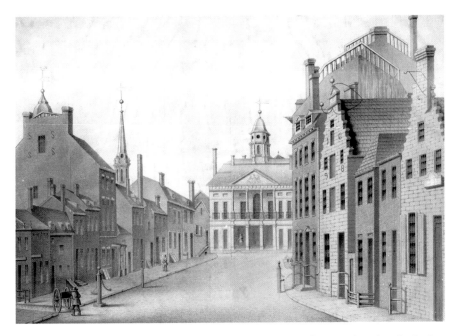

Federal Hall in New York City, the first federal capital, was the first meeting place for both houses of Congress. *From the Library of Congress.*

setting tree trunk barricades afire. The wood of the just-cut trees was too green to burn. L'Enfant was captured and served a long parole in Charleston.

Even when he worked as an architect in New York City after the war, L'Enfant did not escape slavery. Many of the thousands of blacks there were free, many after escaping from the South during the war, and the use of slave labor was not uncommon. There is no evidence that L'Enfant employed slaves even when he superintended the transformation of the old City Hall of New York City into Federal Hall, where Washington was inaugurated in 1789.

To be sure, L'Enfant never voiced any opposition to slavery, but the rations he chose to give to his workers explain his position. A boss who gives his workers chocolate butter for breakfast is clearly one who leads by giving his men incentives and rewards. Slaves working for the benefit of their masters are hard to inspire.

The commissioners made no mention of slaves either, even though they authorized the hiring of 150 workers and L'Enfant only hired 75. Commissioner Daniel Carroll sent him some Irish workers but not any of his slaves. There's no evidence that sending slaves even crossed his mind.

Perhaps the commissioners were initially stunned by L'Enfant. The lanky thirty-seven-year-old with a limp from his war wound was a whirlwind of activity. The unpaid commissioners met in Georgetown a few days every month, and L'Enfant never seemed to be there when they wanted him. If a commissioner rode out to where he was reported to be, he would only learn that L'Enfant had ridden off in another direction. Twice, he went to Philadelphia to confer with the president. So the commissioners were left waiting for the dust to settle.

It didn't take L'Enfant long to antagonize them. In September, the commissioners ordered him to dig up enough clay to make three million bricks, and nothing was done. Asked to show his plan at an auction of lots in October, he refused, though he did buy a lot. He had his men tear down the walls of a house being built by Commissioner Carroll's nephew, which was purportedly in one of the yet-to-be-opened streets on Capitol Hill. Then in December, his men began digging on both the President's Square and Capitol Hill, and no one told the commissioners why.

L'Enfant commanded his men as though they were in a military campaign, and he made clear to them that the commissioners were not in the chain of command. That ran from the president directly through L'Enfant. He was universally called "the Major," and he Americanized the pronunciation of his last name to "Lonfong" and used "Peter" instead of "Pierre." His men responded. Six months after L'Enfant left the project, his commissary, Valentine Boraff, wrote wishing for the Major's return to "Command the Right wing of the City of Washington." Isaac Roberdeau, the young American engineer who became his assistant, closed a letter to L'Enfant with this pledge: "You may be most sure that I will suffer death rather than fail in any respect knowing your honor as my friend and superior officer to be much concerned."

When the commissioners gathered for their January meeting, they found that L'Enfant had gone to Philadelphia to work with books he needed to complete designs of the buildings for which he was already digging the foundations. Left in charge of the seventy-five men was the young engineer Roberdeau, who had orders from L'Enfant in hand, which he refused to share with the commissioners. Not that L'Enfant wanted Roberdeau to completely ignore the commissioners. If he found someone who would agree to make "100 to 200 wheelbarrows introduce the person to the commissioners." And, of course, he should go to the commissioners if he needed money but not to wait for them. "Let nothing interfere with the work."

In Georgetown, Commissioner Thomas Johnson told Roberdeau to do nothing without meeting with the commissioners. Instead, Roberdeau

headed to the quarry that L'Enfant had bought in Virginia, where he had sent twenty-five men to prepare to get stone. The commissioners fired Roberdeau and all the men L'Enfant had hired.

The commissioners blamed L'Enfant for all the hotheaded insubordination. They didn't conceal any of their ire from the president and in several letters hammered away at L'Enfant's not soliciting their orders and his extravagance. Commissioner Johnson was to take the accounts showing L'Enfant's lavish spending to Philadelphia for the president to inspect. "You will find that chocolate molasses and sugar," Commissioner David Stuart wrote, "are the cheapest articles, with which laborers can be furnished for breakfast."

Ironically, it was L'Enfant's inaction that exasperated Washington. He understood tearing down the house in the future street and appreciated exertions on the ground and warned the commissioners that a man like L'Enfant had to be given some leeway. But L'Enfant refused to have his plan engraved, and who would buy lots in a city if they could not see the city plan? Then a rumor circulated in Philadelphia that L'Enfant was showing his plan for the White House to friends. Washington thought he should be the first to see it.

Instead, L'Enfant tried to impress the president with the enormity of the task ahead. He listed all the workers needed, just over 1,000, including 870 "laborers." Given the remoteness of the work sites from a functioning city, he planned to feed all 1,079 men at forty-nine dollars a year for each based on providing each man with a daily ration of "one pound of beef or pork, one pound of flour, a half pound of corn meal, ½ pint of spirits, 2 ounces of chocolate sugar butter, as well as 4 ounces of soap and one pound of rice per week."

L'Enfant outlined how money from a million dollar loan could be spent over four years that would make city lots so valuable that subsequent development could be financed by auctioning them off. No one mistook the 870 laborers he wanted to hire for slaves. They were to be paid seven dollars a month. The commissioners would hire slaves for five dollars a month.

The commissioners told the president that if L'Enfant stayed, they would all resign. L'Enfant refused to work under the commissioners. Although he could think of no replacement for him, Washington sided with the commissioners, and in late February, not quite a year after his appointment, L'Enfant walked away from the project unbowed.

Meanwhile, as their January meeting in Georgetown came to a close, a deep snowfall covered the ground. Having fired all the workers, the commissioners could have let work stand until spring. Indeed, they initially

told the president that was the reason they fired them. No work could be done in the winter. But locked in a battle with L'Enfant, they had to do something to assure the president that the city was progressing.

So before they adjourned and left town, they hired Captain Elisha Williams of Georgetown and authorized him to hire enough men to secure all the work that had been done in the city, especially the stakes marking the survey lines, and to continue building huts for workers eighteen feet wide and twenty feet apart, bringing the number of huts up to twenty. (L'Enfant had plans to build housing for over eight hundred workers.)

The commissioners encouraged Williams to hire men who would work by the job, not on time wages and expecting chocolate for breakfast. So Williams made a contract with Notley Young for the huts. Since Young owned many slaves, some probably worked on the huts. L'Enfant insisted that his men could have made them more cheaply.

There was no mistaking Captain Williams for another Major L'Enfant, though both were wounded war veterans. He was a local man raised on a plantation just off Rock Creek. At fifty-seven years old, he was not likely to challenge the commissioners for control. L'Enfant had worked for expenses and, he hoped, a future percentage of the total expenditures on the project. The commissioners paid Williams £250 a year, or about $700. While serving with the Maryland Line during the war, Williams was a recruiter. His primary job for the commissioners until they laid him off in 1799 was hiring slaves.

At their April 13 meeting, the commissioners handed this to Williams:

> *The Commissioners resolve that to hire good laboring Negroes by the year, the masters clothing them well and finding each a blanket, the Commissioners finding them provisions and paying twenty one pounds a year wages. The payment if desired to be made quarterly or half yearly. If the Negroes absent themselves a week or more, such time to be deducted.*

There are no records of any long discussions on this resolve either between the commissioners or between them and the president and secretary of state, Washington's point man on city developments. Two days before that resolution, they reported to Secretary of State Jefferson that "people had come on tiptoe" to the city to attend their meeting looking for contracts and work. They boasted to Jefferson that they could easily hire two thousand workers. So hiring slaves—and Williams certainly didn't hire more than forty—was not prompted by any shortage of labor. In a letter to Jefferson

written a day after their resolution, the commissioners reported that "nothing very particular had happened."

And in a sense, they were right. Having exploited slaves their whole life, there was nothing particular to them about using slaves to build the new capital. To know why they hired them, we have to know more about the commissioners.

The three commissioners appointed by President Washington in January 1791, Thomas Johnson, David Stuart and Daniel Carroll, had three things in common: they lived near the Potomac most of their lives, owned slaves and had served as directors or officers of the Potomac Company, the joint stock company organized to improve the navigation of the upper Potomac, primarily with canals around all its falls. Dear as the capital on the Potomac was to George Washington, Potomac navigation was Washington's obsession. Washington believed the Potomac route the only viable outlet for crops and commerce from the interior of the country, so taming the river was essential. All the substantial men in the Potomac valley bought into the dream. The reality of getting the work done hardened every manager's or director's view of laborers.

George Washington thought building a canal around the Great Falls of the Potomac would guarantee the greatness of the city of Washington. Drawing by G. Beck, circa 1801. *From the Library of Congress.*

In 1786, a man died blasting rock to make a canal around one of the falls of the Potomac. A superintendent at the Potomac Company joked, "One Blower ran away, one blew up." The laborers were principally indentured servants from Ireland. They were so unreliable and so intractable that bosses who had them beaten were not discouraged, let alone disciplined. Another supervisor told them, "Our hole troop is such villains." The directors deplored the impossibility of securing laborers with good morals.

Thomas Johnson, who succeeded Washington as president of the company, persuaded the directors to hire slaves because "their labor will be more valuable than that of common white Hirelings." The company's first solicitation for hired slaves failed. Washington wasn't surprised because he didn't think masters would risk their slaves on such dangerous work. But Johnson was persistent, and Washington didn't stand in his way. However, the directors did not hire slaves because of a shortage of labor. There were always more shiploads of Irish arriving. Slaves were never a problem for the directors of the Potomac Company nor for the commissioners of the city of Washington. They were a solution to the problems presented by indentured Irish workers and free white workers whom managers could not control.

Johnson and Washington were both born in 1732 and had the same love—the Potomac. Together they were the driving force behind the Potomac Company. From his seat in Frederick, Maryland, Johnson rallied rich Maryland supporters, while Washington rallied Virginians. One could argue that Washington trusted no man more than he trusted Johnson. Washington also appointed him to the Supreme Court. When Washington's second secretary of state resigned in disgrace for sharing secrets with the French, Washington pressed Johnson to take the

A portrait of the young Thomas Johnson that doesn't capture the feisty character who became the dominant commissioner. Portrait by C.W. Peale. *From the National Park Service.*

position. When Johnson announced he was going to retire as commissioner, Washington made a counteroffer. He would abolish the commissioners and appoint Johnson to be the sole man in charge. Johnson turned him down to pursue his dream of cashing in on years of speculating on Potomac lands as the Potomac was opened for navigation and the city of Washington was opened for business. That was Washington's dream too.

Johnson was widely known as "the Little Cock," in part from his short stature and temper and in part for his opportunism. While governor of Maryland during the Revolution, he didn't miss a chance to profit off the war. Along with his brothers, he ran iron furnaces in Catoctin, Maryland. Washington generally despised profiteers but not the Johnsons, who shared the mineral wealth of the Potomac Valley. In 1799, Johnson offered "several slave foremen" for sale, presumably iron workers. He only had thirty-eight slaves in 1790, far fewer than Washington, who had over three hundred, but Washington was probably envious that Johnson built a new industry in Maryland with his slaves. Not that Washington appointed him for that reason. He knew one of the commissioners had to be a good Maryland lawyer.

At first glance, thirty-nine-year-old David Stuart appears to have been the commissioner least familiar with slavery. Although born in Virginia, he was a clergyman's son. He missed the war while studying medicine and languages in Scotland and England. (Daniel Carroll had also studied abroad, in France.) He returned to Virginia and practiced medicine in Alexandria. In 1783, he married Eleanor Calvert Custis, the widow of Martha Washington's son. Thanks to his new family connections, Stuart became a Virginia politician and director of the Potomac Company.

They lived at Abingdon, his wife's thousand-acre plantation along the Potomac,

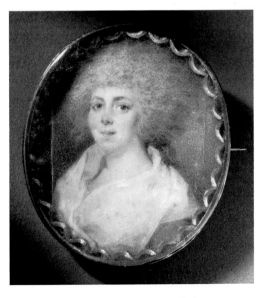

After David Stuart married Eleanor Calvert Custis, the widow of Martha Washington's son, he served George Washington, who made him a commissioner. Ivory miniature. *Courtesy of Mount Vernon Ladies' Association.*

until 1792, when it had to be sold to satisfy her former husband's creditors. It was where Reagan National Airport is today. His wife had a third interest in what were known as the three hundred Custis slaves. She was also a member of the Calvert family of Maryland who owned many slaves. Add to that the fact that George Washington, who was often away from Virginia, asked Stuart to keep an eye on Mount Vernon, where the remainder of the Custis slaves lived. It was there that Stuart talked with the Polish visitor Niemcewicz in 1798. The then-retired commissioner intimated that, on Virginia plantations, the work of slaves "is of little profit if they are not whipped."

If Stuart had been a more active man, his harsh view of slavery might have made a difference to the hired slaves in the city of Washington. But life slowly overwhelmed him. One of his stepdaughters rued that, after his marriage, he became a gloomy man.

If we were to imagine the commissioners debating slave hire, we can picture the Little Cock making the proposition and gloomy Stuart nodding assent. But Daniel Carroll could not simply be outvoted. After the meeting, Johnson would go back to Frederick and Stuart across the Potomac to sort out the headache of his wife's late husband's creditors dunning them. Carroll lived within riding distance of the city. His was a tight little world where he had a hand in running most everything.

He owned a large plantation along Rock Creek just north of the District of Columbia, a hilly area now called Forest Glen. After riding down the road skirting the creek for about nine miles, he could turn right and first check on his brother Bishop Carroll's new Georgetown College and then continue on to the Potomac Company works at Little Falls. Or he might turn left and pass the work at the White House and Capitol on his way to see his nephew on Capitol Hill or his sister, who was Notley Young's second wife, down on the Potomac.

Either way he went, he would see slaves. In 1790, he owned fifty-three slaves. As a young man, he sold slaves at auction. In 1763, he offered "Sixteen Country born slaves, consisting of one Young Fellow, Several Women, Boys and Girls, among them a good Cook Wench, Two Women brought up to waiting on a family."

He had experienced life outside of southern society. He had spent several years in national politics serving both in the Constitutional Convention in Philadelphia and the First Federal Congress in New York. But born in 1730, he was an old man when he faced the decision to hire slaves for the public works. There is no evidence that he voiced any opposition to hiring slaves for the public works, but he may have tempered the process.

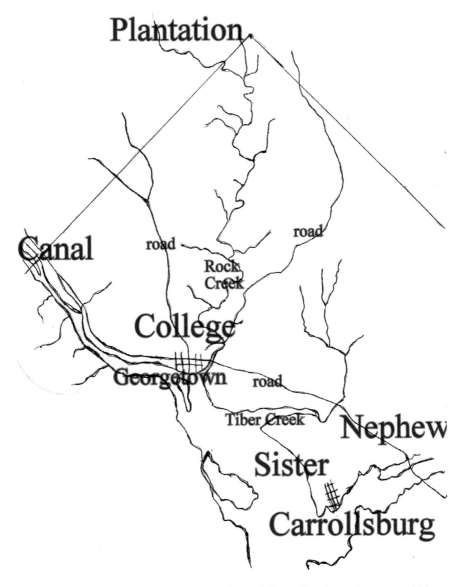

Once he retired from national politics, all of Commissioner Carroll's projects were within an easy ride of his Maryland plantation. *Map by Bob Arnebeck.*

After the commissioners resolved to hire slaves, Captain Williams hired free laborers at the same time. Williams had no aversion to slavery. He owned three slaves in 1790 and had married way up, to the daughter of Brooke Beall, a major Georgetown landowner who owned sixteen slaves. But the Bealls had a

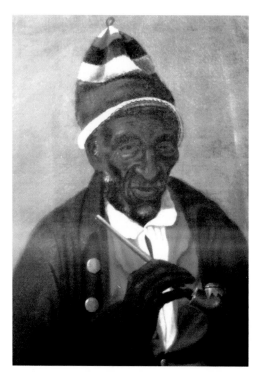

The brother-in-law of the commissioners' slave recruiter freed Yarrow, early Georgetown's most remarkable African American. Portrait by James Alexander Simpson. *From the collection of the Peabody Room, Georgetown Public Library.*

tolerant view of slaves. In 1796, Williams's brother-in-law freed Yarrow, the most famous slave in Georgetown. A brick maker, he had saved his money and bought stock in the local Bank of Columbia, formed in large part to help Georgetown merchants speculating in Washington lots, which impressed the Bealls.

However, it is unlikely that Williams hired free laborers on his own. Although Commissioner Carroll was close to so many of the slave owners who did hire out their slaves, he had helped L'Enfant by sending him Irish workers, likely emigrants sent down by Bishop Carroll in Baltimore. The Carrolls were mindful that even illiterate and irascible Irishmen who came to the country increased the size of the bishop's flock.

The Carrolls had a dream for their Potomac lands well before there was any talk of putting the capital there. Along with other members of his family, Daniel Carroll platted out and even sold a few lots in a small town to be called Carrollsburg that was at the confluence of the Potomac and Anacostia Rivers nestled between the lands owned by members of the Carroll family. It was to be a city of industrious immigrants surrounded by the many Carroll slaves toiling in fields to feed them. So while the commissioners' resolutions called for "good laboring Negroes," the ads placed in the newspaper often dropped the word "Negro." It's likely that Carroll advised Captain Williams to make that change so that it was clear that Irish could still apply. Other free workers found jobs as laborers too, including free blacks.

Such were the men who decided to hire slaves to build the Capitol and White House. Knowing that Johnson had hired slaves to work for the

48

Potomac Company, Washington and Jefferson must have suspected he would persuade his fellow commissioners to hire them too and that it was pointless to comment. However, both men kept pestering the commissioners with ideas on how to build a bigger, cheaper and more skilled workforce without mentioning slaves, free blacks or Irish.

In a March 8, 1792 letter to Commissioner Stuart, the president reminded him of a letter Jefferson wrote to the commissioners urging them to import "Germans and Highlanders as artizans and laborers." The president thought it "worthy of serious consideration, in an economical point of view, and because it will contribute to the population of the place." On April 21, eight days after the commissioners began hiring slaves, Jefferson alerted the commissioners that the time was ripe to make "proper offers to workmen and laborers" in New York, Boston and Philadelphia. He and the president also lauded the superiority of European workers. German indentured servants would "be a good experiment as well in economy," since "they are distinguished for their industry and sobriety, and might do good as an example and model."

Of course the commissioners sent letters off to Europe. But they hired slaves and whites who would work for the same low wage. At the end of the year, Jefferson, who passed through the city and Georgetown on his way to and from Monticello and must have seen the hired slaves, was still worried about workers and alerted the commissioners that men in Connecticut seemed to work for lower wages. When they got his letter, the commissioners had just ordered Captain Williams to hire forty "laboring Negroes" for a year on the same terms as before.

In their reply to Jefferson, they didn't mention that, but they did extol the virtues of the slaves they had hired for a year in 1792. After recounting their efforts to get workers from Europe, they assured Jefferson that "there are Carpenters enough who may be had on the spot" and that they "shall want but a few additional masons next Season." And "as to the laborers, a part of whom we can easily make up of negroes & find it proper to do so. Those we have employed this Summer have proved a very useful check & kept our Affairs Cool."

Jefferson and Washington knew what keeping affairs "cool" meant and who had been checked. Indentured servants from Europe would have provided the same kind of check: labor on a fixed term, a fixed price, with masters having complete control over their lives. It meant getting the job done without another whirlwind like L'Enfant making things hot by inspiring workers with extravagant ideas. Chocolate butter for breakfast was

indeed the least expensive item. He wanted to entice master workmen to come by also giving them money to bring their families, material to build houses and food and furnishings for a year until they could establish their own households and gardens.

The hired slaves probably knew that the commissioners thought they kept affairs "cool." One of Commissioner Johnson's brother's slaves wound up marrying one of Commissioner Stuart's slaves. There must have been gossip among slaves, some of it dumbfounding. How did those hired slaves keep anything cool when they spent all summer cutting trees?

AXE MEN

April 14, 1792, the day after the commissioners ordered hiring slaves, they asked Captain Williams to identify the "best axe men" and send them to the surveyor Andrew Ellicott, and "good mattocks and axes must be provided in plenty." They wanted trees cut "very low" to preclude grubbing and recutting. The mattocks were used to grub up stumps and roots.

There was a lot of cutting and grubbing to do. In future centuries, the original site of the capital would be characterized as a swamp. To contemporaries, it was a woods. The sites of the Capitol and White House and the land connecting them were largely behind or between farms that had been tilled for decades. Such in-between areas were generally kept as wood lots. What spread down from Capitol Hill to what would be the Mall might be called a forest.

Of course, not every tree had to be cut down, only those on public squares and streets. Those streets were uncommonly wide, at least 80 feet, and the avenues wider, 120 feet. Pennsylvania Avenue, which had to be cleared as soon as possible, was to be 160 feet wide. Their dimensions have not been changed, though some like Constitution Avenue, which covers Goose or Tiber Creek that lapped just north of today's Mall, were added after the hired slaves had done their work.

So if we have a good imagination for trees, we can somewhat see what hired slaves did, but we can't be sure of exactly who did it. In 1792, 1793 and most of 1794, the commissioners combined the costs of slave hire with costs for materials and rations, all managed by Captain Williams. All that remains

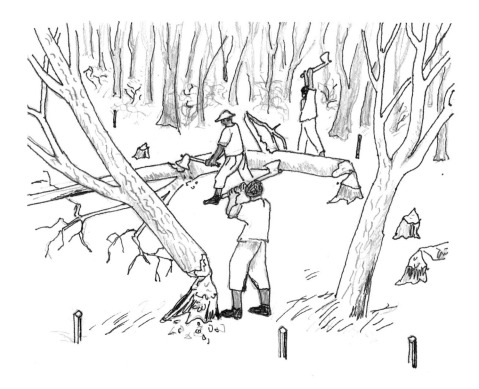

Slave axe men cutting trees to clear a city street, their first job in the city. *Drawing by Leslie Kuter.*

in the records are the varying amounts of money paid to him each month for those expenses, about $2,500.

The commissioners' records have no payrolls until late 1794, so we don't know the names of the slave axe men at the height of street clearing. However, in late December 1792, Williams reported to the commissioners that twenty-four laborers working under Thomas Hardman helped the surveyors for sixty-four days in the late summer and fall of 1792. Twenty of them were sent home before Christmas, so they were probably slaves. The four who remained to "groom the streets" were probably free workers with nowhere else to go.

The commissioners' records do have payrolls for December 1794 submitted by Hardman that list twenty-seven laborers working for the surveyors. That suggests that as extensive as the work that needed to be done was, there could not be more axe men without more surveyors, who were paid handsomely. Cutting on the wrong side of a surveyed line might involve the commissioners in lawsuits with landowners who expected compensation for the loss of their trees.

Judging from that December 1794 payroll, fourteen axe men were slaves, and six were free and probably white. Seven freemen, including the free black Jerry Holland, helped the surveyors move their equipment and mark squares and streets.

Three of the axe men were Plowden's slaves, Gerard, Tony and Jack. The other five Plowden slaves, Moses, Arnold, Lin and the two Jims, were unloading stone from scows and helping stonecutters, masons or carpenters at the White House and Capitol.

The hired slave axe men did good work. In an early 1793 letter to Samuel Blodget, a speculator from Boston whom the commissioners just hired to superintend development of the city, the commissioners complimented the slaves. There were "none so good for cutting before the Surveyors."

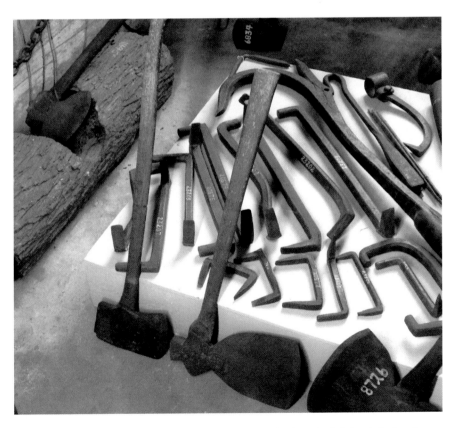

Felling axe, broad axes and hooks to help move tree trunks. *Photo by Bob Arnebeck, from the collection of the Mercer Museum of the Bucks County Historical Society.*

It may not have been an idle compliment. During the year the hired slaves cleared trees, no one died. During the year before the slaves went to work, falling trees had killed several workers. Ellicott shrugged off the early deaths but not the last, one of his assistant surveyors.

"I have had a number of men killed this summer," Ellicott wrote to his wife, "one of whom was a worthy, ingenious and truly valuable character, he has left a wife and three small children to lament his untimely fate." Walter Hanson was from a well-regarded Charles County, Maryland family. The *Maryland Journal*, a Baltimore newspaper, noted that his death was "by falling of a tree in opening one of the streets."

Slaves were probably more prudent in the woods because they were more used to such work. The tradition of hiring slaves out on January 1 probably arose because winter, well before the sap rises and when the ground is firm, is the best time to cut trees for lumber. The tree trunks are easier to remove, and the wood will have longer to season before being used for building in the summer.

There is another bit of evidence suggesting that the hired slaves who replaced the free workers were better axe men. In 1796, an English traveler, Thomas Twining, rode from Georgetown to Thomas Law's mansion a mile south of the Capitol. He noticed the difference in how one avenue had been cleared. "I entered a large wood where a very imperfect road had been made," he wrote, "principally by removing the trees, or rather the upper parts of them in the usual manner. After sometime this indistinct way assumed more the appearance of a regular avenue, the trees having been cut down in a straight line"

The hired slaves probably cut the clearer part of the avenue.

Of course, there was almost no traffic on the streets and avenues and wouldn't be for year. Still, the commissioners placed the highest priority on clearing streets so squares they formed could be divided into building lots and those lots divided between the commissioners and the original landowners. The commissioners hoped to finance construction of the public buildings with money raised from the auctions of lots. The original owners were eager to mortgage lots to raise capital to improve them. The commissioners had that in the back of their minds too. They weren't going after the $1 million loan L'Enfant thought was needed, but the $500,000 loan they tried to negotiate would need lots as collateral.

In April, James Dermott oversaw the slaves, and then toward the end of the year, Hardman took over and Dermott was given the job of surveying the squares, which in turn would be surveyed into building lots. Completing

Map showing division of square number 5 into building lots. A tobacco shed is in the middle of a neighboring square. *From the National Archives.*

that job required heavy lifting and digging. The squares had to be marked with stones, and then, since stones seemed to get moved, the slaves dug ditches around the squares. A typical square was 286 feet by 575 feet. In the

summer of 1792, Dermott surveyed 30 squares, most near the White House where lots had been auctioned off back in October 1791. That meant a lot of ditch digging. And there were over 1,100 squares to go.

This was novel work for any laborer but especially for the slaves. They had probably never worked for a man like Ellicott. He was up before sunrise and, according to one of his assistants, "anxious to know and see that all those under his direction at their respective employments and suffered no person with him to be idle." The commissioners had bought tents for him and his crew so they could camp where they worked. The hired slaves probably camped with them.

Ellicott, born and raised a Quaker in Pennsylvania, did not care for slavery. While working in the city, he never mentioned the slaves in the letters he wrote to his wife. Later, while surveying the line between Alabama and Florida territories, he only employed slaves when his free white hands were too sick to carry on.

Ellicott was not a racist. Back in the spring of 1791, he had hired the free black astronomer Benjamin Banneker, an old friend of Ellicott's family, to help survey a meridian through the future site of the Capitol on which Ellicott could align all the streets and avenues. Banneker returned to his home in May 1791 to work on his famous almanac.

Ellicott proudly explained his surveying methods in a paper read before the American Philosophical Society in Philadelphia. He explained how he was careful to extend lines from the meridian all the way to the boundaries of the city. That those lines had to extend so far made the surveying especially difficult.

All lines were trued by celestial observation thanks to a French transit on a portable tripod of his design. He found that the traditional surveyor's chains were affected by heat, cold and wear, so he made wood "rods formed like a carpenter's square." One can picture laborers moving the tripod and the rods. Not that Ellicott mentioned that, nor the slaves cutting trees, to the society.

Throughout his career, Ellicott surrounded himself with younger men and taught them how to make surveys. Ellicott evidently thought it pointless to teach another man's property. New skills only profited his master. For the slaves, he must have been their first master who didn't act like a master. To Ellicott, the slaves were probably simply hired hands he could use and pity.

The slaves worked as much under a man almost the opposite of Ellicott. James Dermott didn't see them as an object of pity but as a source of future profit. He worked behind the axe men and surveyors and saw that the downed tree trunks were moved to the side of the street where the hands, probably

Andrew Ellicott said his transit and equal-altitude instrument was "the most perfect and best calculated to run straight lines" but not until after hired slaves cut and cleared trees in the way. *Courtesy Andrew Ellicott Douglas and National Museum of American History.*

slaves, of the original landowner would eventually cut up the trunks into cordwood for heat or burning in brick kilns. In 1794, David Burnes, who owned most of the land between the Capitol and White House, had his men

cart off twenty-nine cords of wood cut down by surveyors to open streets. Then Dermott surveyed the squares into building lots.

Commissioner Stuart, who hired him, had doubts that Dermott could handle slaves since he was just off the boat from Ireland. Indeed, while the slaves were doing familiar work, Dermott was learning on the job, learning about slavery. That Dermott showed he could handle slaves raised his standing with the commissioners, all slaveholders. With the money he earned, Dermott bought city lots, houses and slaves. Soon he also sold slaves, especially girls, ready to become servants to people who bought the houses he sold.

In December 1793, the priorities of the commissioners changed. Three speculators, James Greenleaf, John Nicholson and Robert Morris, bought six thousand lots from the commissioners, which took pressure off the surveyors to have lots ready for the commissioners' annual fall auction. At the end of 1794, the axe men were no longer needed. The surveyor who replaced Ellicott wrote to the commissioners, "The streets are all opened and the woodcutters consequently discharged. I have retained in the surveying department seven of the most active and useful hands who will answer every purpose of measuring and bounding & c." In 1795, to somewhat cap the end of the work, the commissioners ordered 320 flatstones to mark all the intersections.

The days of slaves showing that "none were better" for working before the surveyors also ended because as the walls of both stone buildings began to rise, the commissioners needed them for other jobs, but they were probably dismissed too soon. In 1797, a new surveyor, Nicholas King, took over. He wrote that when he first rode around the city, "the woody parts of the city" were "so grown with underwood and bushes that the ranges of the streets cannot easily be found and will require clearing." In the fields, thanks to farming and plowing, many of the stones marking the squares were lost.

Then, thanks to the mess the father of Robert E. Lee made in his attempt to get timber from his plantation up to the city, the commissioners' axe men once again became the men of the hour. The hired slaves had to cut down the tall white oaks from which the roof of the White House was made.

But first a digression on how gangs of men could work in the city and virtually no notice was taken of them. It is understandable that there are no descriptions of the work of the axe men clearing streets. That was necessary work, but except for landowners watching half of their land turn into public lots and streets, that work was never the focus of attention. All eyes were on where the Capitol and White House were to be built.

With L'Enfant gone, Jefferson solicited designs for both buildings. In late July 1792, President Washington stopped in Georgetown to look over designs for the Capitol that were submitted by amateurs and architects from around the country. He had already chosen the design submitted by James Hoban, an Irish trained architect then living in Charleston, South Carolina, for the White House. Washington had nudged the thirty-four-year-old architect to make the house even bigger, and at 170 feet long by 90 feet wide by 50 feet high, it would be the largest residence in America, then commonly called "the Palace."

It would perhaps have been better to first start work on the Capitol, one day to be called the people's house, but President Washington thought there was no time to waste, so work on the White House began almost a year ahead of work on the Capitol.

The commissioners hired Hoban to "superintend" the construction of the building. Hoban wasn't in Georgetown during Washington's visit since he had returned to Charleston to bring back his workmen, which included some slaves. Washington wrote in a letter to his personal secretary back

A photo taken by Abbie Rowe inside the White House during renovation in 1949 better captures the huge dimensions of the building than familiar photos taken from outside. *From the National Archives.*

in Philadelphia that on his return, Hoban would "enter heartily upon the work," and he had already "laid out the foundation which is now digging." The president didn't mention the diggers. It was as if the foundation of the White House was digging itself.

Over a year later, on September 18, 1793, there was a memorable ceremony to lay the cornerstone of the Capitol. President Washington joined the Masonic lodges of Alexandria and Georgetown and followed a grand procession on foot from the White House (then just one story high) to the Capitol. The surveyors, commissioners, stonecutters and mechanics were followed by members of the lodges as well as a band. There was no mention of laborers or of hired slaves. They could have been off in the woods clearing streets.

A boy who was an eyewitness remembered many years later how fun it was to watch all the grand men walk on a narrow plank to get across Tiber Creek just northwest of the Capitol site. The procession probably passed some stonework on the North Wing of the Capitol and then gathered for the ceremony around the freshly dug foundation of the South Wing. It is tempting to say that the slaves who dug the foundation were forgotten. Indeed, there is only one characterization of who did the digging: it was "a considerable force."

The lack of payrolls for 1792 and 1793 is frustrating because that's when the foundations for the White House and Capitol were dug, and we're not certain who completed them. L'Enfant's men had done some digging at both sites. It's not likely that racial prejudice disinclined whites to mention that slaves dug it. The commissioners were quite proud of what their hired slaves did. In that letter to Samuel Blodget in which they credited their good work cutting trees before the surveyors, they added that none were better for tending masons. We'll get to the hired slaves' work with stone in the next chapter. But if the commissioners credited the slaves with that, it makes sense to think they would have mentioned their work digging the foundations.

There were other workers less regarded than slaves—Irish immigrants. Adding to their obscurity as they worked in the city were the eccentricities of the man who oversaw them. According to family legend, Patrick Whalen only spoke in Gaelic, and his slave named Bill Scotland translated for him when needed. He signed documents with his "X."

His major work for the commissioners was digging a canal, or at least twenty-seven thousand cubic yards of it, that widened and deepened James Creek, a small stream south of the Capitol. That was enough digging to make a hole large enough to swallow the entire White House. He only used

fifteen hands. The commissioners and the president, whose pet idea it was, lost interest in the canal when they realized how much it would cost. In the summer of 1793, the commissioners paid Whalen at least $860 for digging the foundation for the Capitol. His slave Bill Scotland probably wasn't needed because all his workers most likely spoke Gaelic.

Who dug the foundation at the White House is more uncertain. It was closer to Georgetown, where Whalen and his men lived.

Thanks to the payrolls we have, we are certain of what the slaves did to make the roof of the White House and Capitol. No one thought of Whalen's Irishmen for doing that. Ireland might be the Emerald Isle, but it didn't have as many trees as southern Maryland.

No one anticipated having to use the hired slaves. Slaves working on plantations downriver were expected to cut all the timber the commissioners needed. By 1796, they had gotten all they could out of the tract they had bought in Westmoreland County. Then General Henry Lee, who reigned over the Stratford Hall plantation in Stafford County, offered to supply all the timber the commissioners still needed.

As a young cavalry officer during the Revolutionary War, he earned the nickname Light-Horse Harry, and in 1807, he fathered Robert E. Lee. He wasn't as accomplished in civilian life. With his lumber sales, he was trying to stave off bankruptcy. The commissioners sent Clotworthy Stephenson, an experienced carpenter, joiner and associate of Hoban's, down to Stratford Hall at the beginning of March 1796 when the timber to be ready for summer building season has usually already been cut, but he found nothing cut in Lee's wood. He could see the problem. The oaks were huge. He suggested they be sawed up into smaller stocks so they could fit in sleds to get them to the river. But they still had to be thick, "not less than 18 inches square." Lee hired Stephenson, who seemed to be so knowledgeable, to raft the timber upriver.

A receipt in the commissioners' records tells the sad story about that attempt. In June 1796, they paid Robert Sutton $142, let him take seven of the hired slaves and provided five gallons of whiskey and two bushels of cornmeal "to raft timber say 94 logs bought of Gen. Lee left along the shore by C. Stephenson." The seven slaves Sutton took with him were paid three shillings and nine pence extra wages per day (about $0.50) for "rafting time on Sundays and Holidays." That expedition took twenty-nine days, and the logs were too short to be used for the roof of the White House. On October 31, 1796, a half gallon of whiskey was provided to laborers "taking raft out of water at the Hotel Bridge" across Tiber Creek.

Hoban still needed four "pieces" of white oak fifty-two feet long and one foot square, as well as six pieces thirty-six feet long and fourteen inches square and, finally, sixty pieces of yellow pine the same size as the smaller white oak trunks. The commissioners advertised in the local newspapers and got no response. Evidently other planters drew a lesson from Lee's debacle.

Then they got a tip. Walter Bowie, one of the most prominent men in Prince George's County, owned a white oak forest on Paint Branch not far from his Collington Plantation that would grow into the town of Bowie, Maryland. They wrote to him at the end of November offering him a price for the trees they needed. All Bowie had to do was get his men to park the logs so they could be floated down to the Anacostia River. Paint Branch was a tributary of Northeast Branch, which was a tributary of the Anacostia River. Bowie sold the commissioners the trees they needed, but they had to do all the work.

Hoban could see the moment passing and just at the most frustrating time of year for him when he needed work done to prepare for the coming building season and when workers, slave and free, took a break for Christmas. To keep a ready supply of lumber, he had been giving slave sawyers extra wages, a shilling a day, theirs to keep. To get the roof beams he needed, he broadened that concept. The laborers, the axe men, would get a shilling a day, too, about thirteen cents.

So in the winter of 1796–97, a team of mostly slave axe men and sawyers cut, squared and rafted the roof of the White House. A free white carpenter named John Brown scouted and picked the trees along Paint Branch. Bennett Mudd, their usual overseer at the White House, attended the slaves for just four of the twenty-eight days it took to get the job done, which is a testimony to the self-discipline of the slaves. All told, twenty camped and worked in the woods as well as Jacob Butler, probably a free black, but he was only there three days.

The extra pay and adventure of it even attracted white laborers. Those at the Capitol were offered the same deal. For thirteen days in December and eleven in January, nine whites and nine slaves working at the Capitol signed up, though, again, not all of them, especially the slaves who longed for home, worked all twenty-four days.

The job stretched from December halfway through January. Those who worry about the slaves suffering the winter cold have never known the pleasure of felling and sawing trees in the winter, especially when there is snow and ice. Plus there was the challenge. Cutting huge white oaks is daunting enough. Raising a fifty-two-foot-long trunk on a makeshift trestle

Detail of the payroll showing the carpenter, overseer and slave sawyers who cut, squared and sawed white oaks into fifty-two-foot-long beams to make the White House roof. The sawyers made thirteen cents a day. *From the National Archives.*

so that a pair of sawyers can work their pit saw and square the trunk down to a more workable size is difficult to imagine, not to mention getting the logs to the water.

The shilling a day was meager, but it was more than axe men ever got before. The sawyer Moses only worked ten days and then went back to Resurrection Manor and that someone he missed. But the Moses belonging to Joseph Queen worked twenty-two days. Four slaves worked twenty-eight days, so their homes were probably not far from Paint Branch. One was named George, perhaps Clagett's George. The Clagetts lived in nearby Montgomery County.

The payroll was not too particular about the names of the masters apart from distinguishing the sawyers named Moses because all wages went to the slaves, plus they had ten gallons of brandy, duly authorized by the commissioners, to share. For that hard work, the brandy was no reward—it was a necessity. Plowden's Moses made ten shillings, about $1.25, before he went home.

The hired slaves were surely underpaid. Their masters would have the last installment of the sixty dollars a year paid to them to help brighten their Christmas. But the point here should not be to pick through the payroll and tie each first name to some faraway master. The point is that a large group of slaves with long saws, broadaxes and felling axes sailed up the Anacostia River with a handful of whites, and they got the job done. The roof of the largest building in America, what would be called the White House,

Photo by Abbie Rowe of the 1949 renovation of the White House showing beams and rafters put in place in 1815 that were similar to those cut by slave sawyers in 1797. *From the National Archives.*

was in the hands of Jerry, Anthony, Tom, Jess and two men named Moses, all sawyers, as well as in the hands of the axe men, always merely called laborers: Nero, George, David, Dick, Nace, Harry, Basil, Jim, Sear, two Charleses and three Jacks.

The timber was successfully rafted downriver by Middleton Belt's men. He hired out two of the slave axe men. There's no record of how many more slaves he used to handle the raft.

Of course, hired slaves also played a role in getting the stone walls of the White House and Capitol high enough for a roof, and they had to wrestle the roof timbers into place. That's the subject of our next four chapters.

4

QUARRIES

In the popular imagination, the labor of the slaves is most connected to the stones of the Capitol. Today in the Capitol Visitor Center, there is a sandstone block below a plaque that explains that the stone was part of the east front of the Capitol quarried from 1824 to 1826 by laborers that included enslaved African Americans.

When writing about the first stone used for the White House and Capitol, some historians assume that slaves did all the quarrying. It seems to make sense. Picture a quarry, and most people picture a mountain. But the Aquia Creek quarry in Stafford County, Virginia, is about forty miles due south of the city of Washington. Where the creek merges with it, the Potomac is wide, flat and feeling the effects of ocean tides. The river at that point does nothing to moderate the heat and humidity. The sandstone hills the creek cuts through aren't high enough to afford relief from the heat. Before air conditioning, the population was stagnant. There were more people living in the county in 1790 (9,588) than in 1940 (9,548). Before emancipation, about 40 percent of the population was slaves.

Until L'Enfant bought the quarry in late 1791, the slave-owning Brent family had owned it for over one hundred years. It's easy to picture slaves working the quarry for the Brents and then for the commissioners. Indeed, if you total up the number of slaves solicited by newspapers for hiring out to work in the quarry, over one hundred slaves worked there. But as the directors of the Potomac Company learned in 1786, advertising for slaves doesn't necessarily mean any slaves were hired.

This memorial in the Capitol Visitor Center honors slaves who quarried sandstone for the Capitol. *From the Architect of the Capitol.*

As it turned out, the commissioners had to struggle to get slaves to work in a quarry. In describing that struggle, we learn about the limitations of their slave hire system. The commissioners began to think about getting slave quarry workers in the summer of 1792 flush with what they viewed

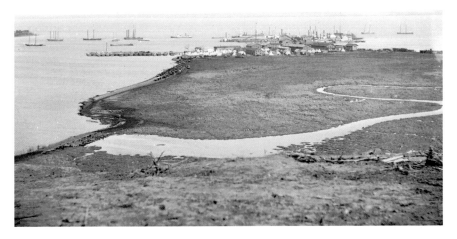

An 1863 photo by Alexander Gardner of sailing ships at the mouth of Aquia Creek a few miles from the commissioners' principal quarry. *From the Library of Congress.*

as their successful transformation of the workforce in the city, thanks to the hire of slaves. It made sense to try them in the quarry because they needed stone desperately. But the slave hire systems didn't spring into action overnight. In April 1792, the commissioners hired William Wright, a mason from Alexandria, Virginia, to manage the quarry. On March 30, 1792, the commissioners bought ten sledgehammers, five hundred wedges, twenty picks, ten beetle hammers, six axes and ten mattocks for the quarries, tools that one would think many slaves knew well.

According to the commissioners' records, Wright had twenty hands working for him early in the summer of 1792. On August 19, Wright promised to have enough stone quarried in winter for one hundred masons to set in the spring. He reported that he had fifty men working for five dollars to six dollars a month. From those records, we don't know if the workers were slaves, but if they were, some were a bit expensive. The commissioners' wage for owners of slave laborers was five dollars a month.

Despite Wright's promises, the commissioners still did not think they were getting enough stone. So in September, the commissioners ordered Wright to hire more hands, increasing his workforce to sixty men and "as many of them should be good Negroes as you can get." Wright protested, "Has there not always been stone ready?" The commissioners thought hard on that reply. Even the Quaker Ellicott was gracious about using the commissioners' hired slaves.

One Brent son, Robert, was still somewhat involved with the quarry. Although his family had owned it, he didn't work at the quarry and likely never had. In 1789 when he was twenty-five years old, Brent married the daughter of Notley Young. Brent and his wife more or less lived at the Young mansion, which served as a second home for Commissioner Carroll. His sister Mary was Young's second wife, and his sister Anne was Robert Brent's mother.

When the commissioners needed someone to take orders to the quarry, Robert Brent was at their service. His mother still lived near the quarry. Often in the company of Carroll at the Young mansion, Brent must have known of the commissioners' enthusiasm for using hired slaves to check the demands of free workers.

Apparently Brent offered to get the slaves the commissioners wanted. The commissioners asked him to get forty slaves for £12 Virginia currency a year, or a little under $4 a month. Brent told them that was not enough, so the commissioners ordered the hiring of twenty-five slaves at £15, $4.50 a month. (Virginia money had a different exchange rate than Maryland money.) Of course, the money went to the masters. The hired slaves would cost the commissioners $0.50 a month less than Wright's men. The commissioners fired Wright, and Brent placed ads in Virginia newspapers for slaves. Knowing that the president and secretary of state kept an eye on what they were doing, the commissioners certainly didn't want to fire Wright without an accompanying bold stroke to show they had the situation well in hand.

The ad Brent put in the newspapers certainly impresses some modern historians. One wrote, "It is likely the commissioners wanted slaves hired quickly in order to keep the quarry in operation throughout the winter months. It is also likely that Brent already had a crew of slaves at work."

But other than the ad, we don't have evidence of a crew of slaves working in the quarry. In March, we do get evidence of disgruntled free workers at the quarry. After the commissioners fired Wright, Robert Brent still did not take over the quarry operation. Collen Williamson, a Scottish stonemason the commissioners hired to oversee stonework at the White House, sent a mason named John Watson to run the quarry.

In March, still uncertain that the quarry was productive enough, the commissioners prevailed on Williamson to go to the quarry and report on conditions there. Judging from Williamson's report, despite Brent's ad, there were no slaves working at the quarry. Watson had "exerted himself" and was doing good work. He had "about thirty four men at work, the greatest 16 of which is recommended to me as good hands, and willing to forward the work but hath been threatening to leave the work if they be not allowed seven dolors per month for sumer season, and be allowed forty hands."

Those were not the complaints of hired slaves. What they were paid was immaterial to them since the money went to their masters. There was another complaint: "If any of them is taken sick there raciones is kept off." Hired slaves had to be fed even if they were sick. Unlike free workers, they could not simply wander off and find or buy food.

Of course, it is possible that Williamson, who came from Scotland, didn't accept that slaves could be quarry men and didn't count those who were there. In August, the commissioners told Bennett Fenwick, a contractor in the city, to take "up to 6 hands" for a few days to fix stone at the quarry. Fenwick hired out his own slaves, Tom, Harry and Joe, so he probably took hired slaves down to Aquia. Fixing stone, in that era, probably meant painting or using a trowel to cover stone ready for shipment with crushed seashells to prevent it from absorbing water during the humid late summer. But it's unlikely anybody would mistake laborers fixing stone as quarriers.

In 1806, Benjamin Latrobe, then directing the construction of the South Wing of the Capitol, inspected a sandstone quarry at Aquia and in his papers left a description of how the work was done, a process called channel and wedge quarrying:

In working these quarries, the workmen having cut the face perpendicularly, first undermine the rock;—an easy operation, the substratum being loose sand. If the block is intended to be 8 feet thick, they undermine it 5 feet, in a horizontal direction, in order that it may fall over when cut off. They then cut two perpendicular channels on each hand, 1ft. 6in. wide, at the distance from each other of the length of their block, having then removed the earth and rubbish from a ditch or channel along the top of the rock, they cut into the rock itself, a groove, and put in wedges along its whole length. These wedges are successively driven, the rock cracks very regularly from top to bottom, and it falls over, brought down partly by its own weight. Blocks have been thus quarried 40 feet long, 15 feet high, and 6 feet thick…These masses are then cut by wedges into the sizes required.

An 1891 drawing of sandstone quarrying, which matches written descriptions of how sandstone for the Capitol was quarried. *Courtesy of Cornell University Library, Making of America Digital Collection.*

Freestone, also called ashlar, formed the basic building block of the Capitol's wall and could not be less than two feet in length, one foot thick and one foot broad. Bill stone used for corners could not exceed six feet in

length and three and a half feet in diameter. Smaller blocks called rubble stone were needed but not prized. They could be less than two feet in length.

Latrobe didn't mention if free men or slaves did the work. In 1796, George Blagden, an English stonecutter who took over supervising the stonework from Williamson, inspected the quarries, and his report only talked about the stone, not the workers.

But back to the problem the commissioners faced in 1793: getting out more stone in a hurry. As we shall see, Brent did hire some slaves, but that's not what solved the commissioners' problem. There certainly were not enough slaves hired in 1793 to check the demands of the free workers at the quarry. The commissioners bragged about their slave hire in the city of Washington, but they never alluded to the work of slaves hired at the quarry.

With the pressure to get stone, the commissioners had no choice but to give in to the free quarriers' demands: a seven-dollar wage in summer and "1/2 pint of whiskey to each man." Plus they tried to entice stonecutters working at the White House to spend the winter at the quarry. Stonecutters were their highest-paid workers. To get them to go forty miles south to the quarry they were offered ten dollars a month, twenty-six days' rations and no deduction for bad weather and sickness. The masters of hired slaves were never offered a deal like that. Hiring stonecutters made sense, and it was easier than hiring slaves. The superintendent building a Potomac Company canal had told the commissioners that, by putting stonecutters at work in the quarry, they would get better stone that would need less work when it was delivered to the masons for setting. Plus, the easier way to build the workforce was not by advertising for slaves but by using the network of friends and relations that free workers had.

The commissioners hired Williamson, who had been working in New York City, after they got a tip from his cousin John Suter, an innkeeper in Georgetown. Then Collen Williamson sent his son, Captain Lewis Williamson, out to the quarry, and he, in turn, got his friend Robert Hunter to work at the quarry. When Hunter went home to Philadelphia to get his wife, he offered to bring back other stonecutters, for a fee. The commissioners agreed to pay Hunter a day's wages for each good man he could get. However, there is nothing in the commissioners' records even suggesting how many stonecutters spent the winter at the quarry.

The slave hire network in Virginia worked much more slowly. Few plantations had slaves experienced in quarrying ready to be hired out. George Mason, the man credited with coaching George Washington on the virtues of revolution and the Constitution, ruled over Gunston Hall in

Mason's Neck, Virginia, situated between Mount Vernon and Aquia. His son John recalled his father explaining how his slaves provided every conceivable service he would ever need: "carpenters, coopers, sawyers, blacksmiths, tanners, curriers, shoemakers, spinners, weavers and knitters." He didn't mention a stonecutter, stonemason or quarrier.

In the summer of 1792, when Mason wanted stone, he hired two masons "imported from Scotland," whose terms of indentured service were up. He sent them to Aquia to get the stone they needed. Those two men, James Reid and Alexander Wilson, both worked as masons at the White House in 1795.

The nature of the work at the quarry probably gave masters pause, just as blowing and removing rock to make a canal around Great Falls did. It took masters a long time to answer the Potomac Company's call for slaves. In the summer of 1794, it finally managed to hire sixty slaves but, a company manager noted, "with great difficulty" and primarily to just replace white workers when they "wilted" in the summer heat.

Not that free workers swelled the workforce at the quarry. Despite the effort to increase their numbers, in August 1794, there were only thirty-five hands, just one more than in March 1793. Not many of the workers listed were hired slaves. There were John Porter's slave Moses, John Linton's Jack, Benjamin Burrough's Bob and Alexander Watson's Negro Alexander. The slaves' masters earned fifty dollars a year, and it appears the wages for free workers stayed the same, most at five dollars a month, a few earned six or seven dollars. The workers shared thirty-one gallons in whiskey during that hot month.

It was hard work and hard to stay healthy. Of nine men listed on one payroll in June 1794, the median number of days worked was fourteen. It is hard to believe that slaves worked there all for the profit of their master. In the nineteenth century, masters sometimes let their slaves keep a portion of the wages they earned. There is not much evidence of that in the eighteenth century. One master, John Linton, begged to have his slave Jack Fuller back a month before the end of his year-long term of labor and still be paid his wages. Linton was "in great distress for cash," and perhaps he wanted to sell Fuller.

So evidently, at least from 1792 through 1794, there was not a gang of slaves working at the quarry, and the slaves who were there worked with a team of white quarriers and stonecutters. Not that the ads soliciting slave workers stopped.

At the end of 1794, the commissioners more or less gave the quarry back to the Brent family. Robert Brent's brother, Daniel, and a cousin Colonel John Cooke became managers and signed contracts as the firm of Cooke and Brent.

Collen Williamson characterized the new arrangement as Commissioner Carroll giving the quarry to his nephews. The commissioners advanced money to the firm. After the deal was finalized in December, Cooke and Brent advertised that they wanted to hire "sixty strong, active Negro men for whom good wages will be given—they shall be well used and fed."

Notice the ad did not say *to whom* good wages would be given. But that was not the commissioners' business anymore, and there are no records of who continued to work the quarry and whether they were indeed "well used and fed." Cooke and Brent did not have only slaves working their quarry. In May 1795, they explained their late deliveries by telling the commissioners that "new hands were hard to get" and "wages and provisions higher than in the Fall." They evidently did not lock their labor costs by hiring slaves on January 1 to work until Christmas for fifty dollars.

Cooke and Brent managed to send forty-three shiploads up the Potomac to the commissioners, 1,895½ tons of stone. As we shall see in the next chapter, hired slaves probably got their hands on all of it as it was hauled to the Capitol and White House.

Forty-three tons was the half of it. Fortunately for the commissioners, two of the stonemasons they lured down to Aquia discovered better stone next to Cooke and Brent's quarry. John Richardson had Irish roots, and John Henry had been recruited by the Scot Williamson, which doesn't mean they wouldn't hire slaves as quarrymen, but there is no evidence of it. Richardson's stone was lauded "for fineness and closeness of texture." That's where Benjamin Latrobe admired the work of the quarriers in 1806. The quarries in what became known as Government Island were worked through the nineteenth century.

To meet the demand for stone, the sons of Virginia plantation owners gave way to stonecutters who actually knew the business. Not that Robert Brent, who handled the Washington end of Cooke and Brent's business, lost any face. In 1801, President Jefferson appointed him the first mayor of Washington.

The commissioners got stone delivered from other privately owned quarries, and no records have surfaced suggesting if slaves did that quarrying. It was a tough business. Reid and Smith boasted that they had forty-five hands getting stone out, but the stone proved no good—the vein failed.

Before assuming that some of those hands had to be slaves, we should remember that many emigrants from Ireland worked for the Potomac Company making canals around the falls. They were not merely diggers. They had to break and remove stone and also bank the canal with stone blocks. Their supervisor, Richardson Stuart, was a noted Baltimore stonemason.

An 1896 drawing of sandstone from Aquia quarry being "fitted" prior to shipment. In the 1790s, much stone was damaged due to inadequate cranes. *From the Library of Congress.*

Patrick Whalen, who managed to get a start on a canal through Washington before money woes persuaded the commissioners to stop the project, called himself a quarrier. The Washington canal he dug was banked with logs. In 1793, the commissioners sent him and his men to Aquia to widen the creek into an eighteen-foot-wide canal to make it easier to load stone on ships. He likely banked the canal with stone his men quarried.

The deal with Cooke and Brent did not take the commissioners completely out of the quarrying business. In late 1793, a landmark outcrop of rocks known as the Key of All the Keys near the mouth of Rock Creek pointed the way to a vein of harder Piedmont sandstone. Experts said it could be used for foundation stone. The commissioners reported that the stone extended "a considerable distance this way," meaning that much of it was on land owned by the public or by landowners interested in the success of the city. (The stone has since been covered with earth to accommodate highways.)

A 1971 photo by Jack Boucher of what remains of part of the Great Falls lock number 1. Irish quarriers built lock walls as other Irishmen dug the canal. *From the Library of Congress.*

The land speculator James Greenleaf, who had just bought thousands of lots in the city, offered to quarry the stone and share half the expense and half of the stone with the commissioners. He sent down a young Irish mason named William O'Neale. Although Greenleaf paid half of O'Neale's salary, the commissioners turned out to be his boss because the speculator was usually away from the city.

O'Neale was not another Patrick Whalen who signed with an X and only talked in Gaelic. As we shall see, he soon looked askance at the way the commissioners operated and became an innkeeper instead. His daughter Peggy's wiles tied the Andrew Jackson administration into knots. As the owner of the Franklin House, which became a popular place for politicians, O'Neale owned several slaves, but when he came to the city in 1794, he preferred Irish hands.

The commissioners told Williams to send three hands to work in the quarry, but they were not slaves. One work roll sent in by O'Neale shows that three of the hands working at the quarry had last names, though they marked with an "X." O'Neale collected the wages of the three others, but they had full names, and two were paid less than the others.

They were probably O'Neale's indentured servants. All the men were listed as "Stone Quarriers."

But O'Neale could not avoid using slaves. The commissioners also put him in charge of loading stone at the Key of All the Keys and unloading stone at the commissioners' wharves closer to the Capitol and White House. Then the stone had to be hauled to the building sites. There is nothing wrong with the memorial in the Capitol Visitor Center. Enslaved African Americans always had a hand in quarrying stone but certainly not a major role in the early years, despite the commissioners' desires. However, in those early days, hired slaves had to hug stone hoisted by makeshift cranes for days on end.

5

HAULING

In the late eighteenth century, artists and their patrons prized landscapes. The tastes of the time dictated that the views be bucolic—that is, that they portray an environment conducive to relaxation. The Romantic Era yet to come would make every hill into a Mount Everest and nature a challenge. In its early days, the city of Washington attracted a few artists, and since there were so few buildings in the city, they approached their subject as a landscape. To suggest that changes were soon to come, they usually had a token worker in the foreground.

In 1803, standing roughly at the foot of Capitol Hill, the English surveyor Nicholas King made a drawing looking over at Blodget's Hotel, the largest hotel in America built from the proceeds of a lottery—well, almost built. An empty cart drawn by one ox and manned by a man in a great coat, perhaps Patrick Whalen, is in the foreground along with two hunters. The few buildings along the F Street ridge are in the background. The drawing suggests that with an ox cart much had been done and much would be done.

Of course, as in most descriptions of the city, the slaves were forgotten, as were the shallops, scows, wharves, cranes, stone wagons, drays and horses, just as the steep hills were forgotten, too.

As the city surveyor, King did leave us with a dose of reality. In preparation for leveling the streets so they would drain better, King took elevations of points throughout the city. Almost two hundred years later, architect and historian Don Hawkins used those measurements to make a detailed contour

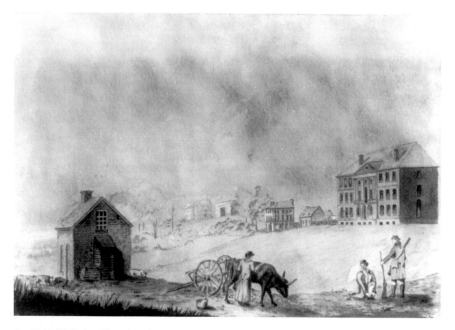

An 1803 Nicholas King drawing of the view from the foot of Capitol Hill looking west beyond Blodget's Hotel. The ox cart suggests the hard work done and yet to come. *From the Library of Congress.*

map of the city. Unlike the usual contour map, he didn't write elevations on the map, but each contour marks a five-foot rise of ground. Hawkins's map, so rich in topographical detail, captures the pain of anyone, and especially the hired slave, who had a hand in getting stone and lumber up from the river and to the White House and Capitol.

The shortest distance stone had to be hauled was from the commissioners' wharf directly below the President's Square, about three-quarters of a mile. Hawkins's map shows how daunting it actually was. First the drays had to muck through flat, low ground liable to flooding, and then there was a steep climb of forty feet to reach the rather uneven plain to the building site. Plus, David Burnes owned the land and lived in a stone house nearby and kept a sharp eye on everything. He was quick to complain to the commissioners about any damage to his fences.

For deliveries for the Capitol, the commissioners ordered a wharf built at the old ferry landing along the Anacostia River about two miles due east of the site. Their wharf was at the end of the ferry road, which connected to an old road that ran just south of the Capitol. Once a wagon got up that very steep sixty-five-foot climb, there was a relatively level pull to the Capitol

To get stone wagons from a wharf at the mouth of shallow Tiber Creek to the White House required avoiding a marsh and then a steep climb. Map courtesy of Don Hawkins. *From the Library of Congress.*

stone yard, but it was over a mile, and carters got accustomed to cursing the "hill at the Ferry and the badness of the roads" in the same breath.

There was also a wharf where Seventh Street would cross Tiber Creek called the Hotel Wharf because it was where the stone for Blodget's Hotel was unloaded. The commissioners used the centrally located wharf to unload 160 flatstones used to mark the intersections in the city. Then, almost a mile due west of the White House, the Funkstown or Hamburg wharf, where stone from the public quarry was loaded for shipment to the Capitol,

The road from the Ferry Wharf to the Capitol was two miles long, but only one steep hill had to be mounted. Map courtesy of Don Hawkins. *From the Library of Congress.*

became a wharf for unloading lumber to take to the White House. (In 1765, a German immigrant named Jacob Funk almost founded a city in the area.)

That there were four wharves should not leave the impression that getting boats from one to another was easy or commonplace. The city was just below the fall line of the Potomac. The port of Georgetown managed daily tidal fluctuations and spring floods easily enough, but its wharves jutted out from rocks into the deeper part of the river. Tiber Creek was shallow, and its shores were marshy. Not for nothing did L'Enfant want to turn it into a canal and build that before the public buildings. It would have made stone deliveries easier.

Without that canal, getting from one end of the city to the other by water was too dependent on tides and winds. So there was a considerable fleet of carts and wagons making ruts in the hard clay of the city. One contractor supplied wagons drawn by four horses at four dollars a day, two-

horse carts for two dollars a day and a single-horse cart for ten shillings a day. Unfortunately, no accounting was made of the number of horses and oxen used by the commissioners and their contractors. From what we can glean from the commissioners' records, even hauling lighter loads from the rivers up to the Capitol required two horses. To haul sand in barrels, one contractor used three carts and six horses. Carters did have lighter loads, including "carrying Negroes to the hospital."

The main problem carters faced was the distance. Middleton Belt complained of being "often obliged to go to Funkstown wharf to the Capitol and from thence to the Eastern Branch [Anacostia River] and often at the distance of many miles in a day."

O'Neale, who only hauled stone, divvied up 100 perches, or about 1,600 feet, between 81 wagon loads and 137 cart loads. Judging from a 1794 letter O'Neale wrote to commissioners, every load was agonizing to him and worse for the slaves. He described how many hands unloaded ships bringing stone from the quarries and roughly what they did. It took six hands two days to unload one ship and eight hands three days to load that stone onto horse-drawn wagons to be hauled up the hill to the building sites. O'Neale chafed at the hands "skulking" during the laborious process.

To be sure, there were cranes available to hoist stone at the quarries and unload stone off the ships and then onto the wagons. The cranes were similar to those used for centuries, essentially a tripod made with wooden posts topped with ropes, pulleys and tackle. To move the crane, its three legs could be methodically shifted.

O'Neale thought much of the shifting around was pointless. He told the commissioners that the wharves should be modified so that the wagons carrying the stone away could be placed so that the crane at the wharf could load the stone directly onto them. That meant that "one part of the work would drive the other & no time for skulking, less hands employed, & less use for them in this business, as one wheel of a mill moves all must follow."

O'Neale thought his methods could also free four hands at the Aquia quarry. There the stone was first loaded onto a scow, which was rowed or sailed down the creek to the wharf at the river, and then the stone was taken off and loaded onto a shallop, a large boat with more sail. If the stone was loaded directly onto it, half the number of men would be needed, freeing four hands who could work in the quarry and not on the wharf.

Like all who foresaw processes that would be common in the future, O'Neale simplified the problems the commissioners faced. Describing those

Photo of crane unloading stone for construction of the Capitol in the 1850s. *From the Library of Congress.*

problems as best we can probably best explains why they didn't react to O'Neale's proposal.

To begin with, neither the scows nor shallops were seaworthy. The commissioners' large scow leaked so badly that having two hands bail water out in buckets barely kept it afloat. So there was good reason to load the larger boats away from the quarry so if they sank they would not stop all other shipments.

O'Neale's report of one mishap was a bit laconic. A ship sank in Tiber Creek. A large amount of stone fell out as it sank next to the wharf, and the stone "must be removed." That happened in February and was likely a job for the hired slaves.

In the winter of 1798, a schooner loaded with stone sank at the Aquia quarry wharf in ten feet of water, delaying that shipment at least a month. Likely, the stone had been loaded at the wharf from smaller scows brought down the creek. If the schooner had sunk back there, it might have blocked the whole stone-removal operation for a month.

The reputation of the wagons used to haul the stone was not good either mainly because horses pulled them over punishing roads. The commissioners paid a wheelwright to repair the "stone carts," so it seems the weight of stone was too heavy for the wheels.

At the same time, the wheelwright was paid to make a model of a better crane for raising stone from the boats docking at the wharves. There were no

engines available, so the wheelwright was jigging counterweights and pulleys in his model crane. Generally, the cranes were deemed the problem in the system of delivering stone.

Cooke and Brent complained that the cranes were too small. A cart was sent all the way to Commissioner Johnson's ironworks in western Maryland to bring iron castings for the crane at the wharf where stone for the Capitol was unloaded. Then Cooke and Brent complained that there was so much stone at the dock that the crane couldn't move and the ship's tackle got tangled with the crane's and "the lives of the hands endangered by lifting the heavy bill stone."

The commissioners blamed Cooke and Brent for making deliveries after the commissioners sent their hired slaves home for the year. Then they had an idea. The commissioners tried to solve their problems by pushing them onto all their contractors. Back in 1792, the commissioners had contracted with John Mason for four thousand perches of foundation stone delivered "in a convenient place a little within or above the mouth of Goose Creek." In 1795, the commissioners contracted with Mason for three thousand perches of foundation stone and offered to pay more if he got it to the Capitol "rather than be compelled to take upon ourselves the burthen of waggoning it to the Capitol." (Of course, the hired slaves, not the commissioners, actually took on the burden.)

John Mason refused to accept those terms and wanted the commissioners to receive the stone on the wharf since he had no control over it during hauling. The commissioners were adamant and forced stone contractors to do it their way.

While the commissioners still maintained what were known as "public carts," they sold many to contractors. That didn't make them any less disreputable. When the commissioners warned a brick contractor to stop littering the Capitol Square with bad bricks, the contractor blamed the bad carts he bought from them. The commissioners sold their scows to John Templeman.

The changes forced one stone contractor to hire ten to thirty extra hands "plus the expense of furnishing and maintaining cranes, carriages, horses & vessels." Cooke and Brent carped that the crane needed better tackle and that they now were "obliged to hire hands to assist in unloading vessels besides pay an additional price for drayage in consequence of the draymen hiring an additional number of hands to load the drays." The number of hands on boats and drays couldn't be expected to unload the large stones of two to three tons.

Although accused of "skulking," the work the hired slaves did at the wharves was obviously appreciated by the stone contractors. The commissioners could not be persuaded to change their no-hauling rule. They crowed to the president in a January 29, 1795 letter that they had contracts for delivering twelve thousand perches of free stone to the building sites at seven shillings and six pence less per ton than previous deliveries. Plus their laborers were no longer "perpetually called off from their several employments to assist in unloading crafts & carts."

The hired slaves lost their most laborious job, but their stone hauling days were far from over. While they no longer lowered stone from boats and hauled it up hills, they still raised stone up the growing walls of the Capitol and White House. One of their main jobs was "tending masons."

6

STONECUTTERS AND MASONS

When they looked to Europe for workers, the president and the commissioners yearned for stonecutters because they feared those already in America "could command their price." Commissioner Johnson initially thought stone was cut with a saw, which suggested that brute strength was the key to the operation. He was disappointed to learn that men using a hammer and chisel perfected the stone blocks brought from the quarry so they could be set on the walls of the building. Using such gross instruments for finishing work, obviously the men doing it had to be highly skilled, and there was no way to speed up the work except by hiring more stonecutters.

But setting the stone seemed to be a different matter. Just as the commissioners bought quarried stone by the ton or perch, they thought they should pay for its setting by the amount of stone set. They decided that they could make their total bill for the buildings lower by hiring slaves to work in the quarries, getting masons to work by the piece and praying for naïve or indentured stonecutters fresh off ships from Europe.

They never bought any indentured stonecutters from Europe, and the few slaves they got to work at the quarries did not lower the wage rates there. However, their crew of mostly slave laborers did eventually persuade some masons to make a piecework contract for stone setting.

A skilled worker's first objection to piecework is that he will be dependent on the material being at his side. The more he walks around to get materials, the less stone he will set in a day and the less money he will make. So the commissioners saw to it that there was at least one laborer available to

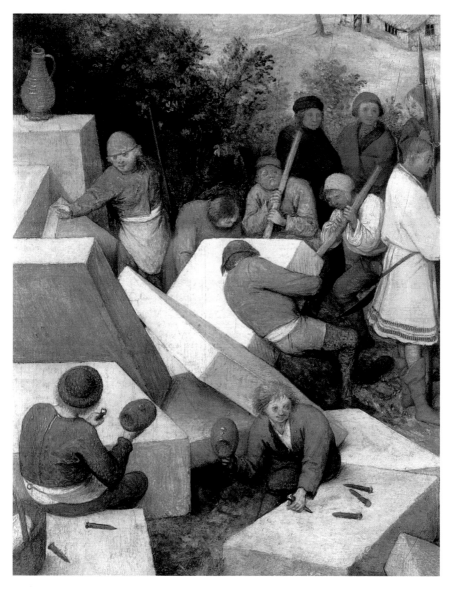

There is no better depiction of laborers tending masons than this detail from Pieter Bruegel the Elder's *Tower of Babel* in the Kunsthistorisches Museum, Vienna, Austria. *Image by Artboom.*

tend each mason. Masons working for day wages were more efficient with attending laborers. In January 1793, the commissioners could boast of their slaves that there were "none better for tending Masons."

"Tending masons" is not an archaic phrase. It is used today in contracts made by the Laborers International Union. Their contracts explain that "tending shall consist of the preparation of materials and the handling and conveying of materials to be used by mechanics" and then continue for seven pages. A 1794 contract with the commissioners is not out of line with modern contracts in calling for "a sufficient number of laborers to hoist and haul stone on to the scaffolds." Then as now, laborers tending masons could fix stone. Then as now, the laborers should do all the ditching required when laying foundation stone.

Modern laborers can raise scaffolds under fourteen feet, but carpenters must raise those that are higher. In 1797, George Hadfield, who superintended construction at the Capitol, decided that the hired laborers should start putting up the scaffolding, which soon rose to over fourteen feet. Indeed, the buildings were eventually completely surrounded by scaffolding going up to the roof.

The stone to be set had already been prepared by the stonecutters who worked on the Capitol or President's Square. The laborers' job then was to get it from the stone yard or stone workers' sheds using the stonecutters' carts. As the masons built up the foundation walls, the laborers used pulleys to get stone down to carts next to the wall and then pushed the carts to the masons and, under their instructions, lifted it so they could set it in place. Inclined planes and poles to leverage the stone probably helped. Laborers probably also brought mortar to the masons and perhaps mixed it. There was a horse-driven machine to mix the lime. When a horse wasn't available, the hired slaves did all the work.

That seems a plausible explanation of what the slaves did. No one described it at the time. When the stone had to be raised from the ground, scaffolding, pulleys and cranes had to be used to get the stone up to the masons standing on the scaffolding along the walls of the building. A Baltimore contractor hired to build a stone bridge over Rock Creek in 1792 first brought cranes to the city to raise stone, and he sold at least two to the commissioners. One of the cranes used to hoist stone may have been horse powered. At least, in 1794, there was a request for one horse to help hoist stone at the White House. Unfortunately, no one described the cranes, how they were operated and who operated them. No payroll lists crane operators, so we can assume laborers, likely the hired slaves, pulled the ropes.

One piecework contract that a group of masons offered to make with the commissioners put a monetary value on tending. They offered to build the foundation of the Capitol "at 4/6 per perch—having all materials laid down

convenient to the Building—And if found with sufficient attendance we will do the same for 3/6 per perch."

"Sufficient attendance" was worth a shilling per perch of "well set" stone. One perch of stone wall is 16½ feet long, 18 inches high and 12 inches thick. A shilling saved on that doesn't sound like much, but the foundation walls of the Capitol were on average 14 feet high and 9 feet wide. The North Wing of the Capitol was 120 by 126 feet and 70 feet high. In a building with those dimensions, saving 25 percent per perch was a major savings.

The commissioners didn't make that contract because they viewed it as a desperate response by Scottish masons to take work from Irish masons who had made a piecework contract over a year earlier. Plus the Irish mason who made the contract flattered the commissioners for their hiring slaves. He wanted hired slaves to tend his masons. The Scots generally preferred white laborers. At least, on a May 1795 payroll for eighteen laborers at the White House, judging by their names, all were white.

The mason who proposed the piecework contract learned the value of slaves at Mount Vernon. On the plantations of the South, there was a tradition of requiring skilled indentured workers to teach their trade to the slaves on the plantation. In 1786, George Washington drew up a contract with the stonemason Cornelius McDermott Roe that required him to "instruct to the best of his skill and judgment, any person or persons who shall be placed with him for that purpose, in the Art and misteries of his Trade."

There is no evidence that McDermott Roe trained any slaves at Mount Vernon. He soon had Washington hire two of his brothers to help with the masonry work. But working at Mount Vernon taught McDermott Roe that slaves were easy to work with; indeed, there was none better for tending masons.

After he served his time at Mount Vernon, McDermott Roe moved to Georgetown. Collen Williamson didn't hire him, but Roe attracted the attention of James Hoban, another Irishman, who superintended the work at the White House. Not impressed with the Scottish masons, Hoban had promised the commissioners to get some Irishmen for the job.

The commissioners and McDermott Roe signed the contract on January 30, 1794. Laying the foundation walls of the Capitol would begin in the spring, and the commissioners hoped to have all that work done by the piece. When the Scottish masons who worked in 1793 returned to start setting stone in the spring, they had no reason to expect any changes. Between April and August 1793, working under Collen Williamson, they laid the foundation of the White House four feet below ground and raised the walls twelve feet

Photo by Abbie Rowe of the original foundation stones of the White House revealed during the 1949 renovation. *From the National Archives, Truman Library.*

high so that the first floor could be closed in by the carpenters and the whole first story painted.

Observers were impressed by the "spirit" with which the masons worked. Since one story of a stone building had to sit at least a year before the second story was added, the masons expected to begin working at the Capitol. They

didn't expect to be told by the commissioners that they had to work under McDermott Roe and that those whose wages were due to be renegotiated had to work by the piece. To mollify old hands, the commissioners asked Collen Williamson, a salaried worker, to inspect the work done by masons doing piecework.

The masons working for wages balked more at working under the Irishman than working by the piece. The commissioners fired them because they were "too idle" at their work. Williamson backed his masons, and the commissioners fired him, saying he was simply too old, at sixty-five, to keep track of the work. Fifteen masons left the city.

All that unleashed latent animosities between the ethnic groups. The commissioners let all know whose side they were on, warning that they would punish those "at the Capitol who have issued threats against Mr. Hoban and Dermott Roe." The bad impressions the commissioners formed of Irish laborers working for the Potomac Company were forgotten as they realized that skilled Irish workers worked for less than the Scots and English.

Four Scottish masons wrote to the commissioners denying that any masons were ever idle and insisted that their work was better than what the masons working under McDermott Roe were doing. They refused to work under him, telling the commissioners, "No man who is a Tradesman will submit to work under those who are not." They insisted that their work "will stand the test of the severest examination," while "McDermott Roe's is totally unfit for such a building, and must be undone or the House will be ruined."

McDermott Roe slowly hired a workforce. The commissioners offered lodging for his men in one of the temporary buildings on the Capitol Square. In August 1794, he only used four hired slaves from the commissioners. But in the late spring of 1795, there were enough hands to begin setting stone for all three sections of the Capitol. After the foundation was dug in the summer of 1793, work began on the North Wing. Work on the South Wing had been delayed to accommodate the official laying of the Capitol cornerstone on September 18, 1793. There was a growing realization that the middle building, the Rotunda, could not be done by 1800, but a wall was laid connecting the two buildings.

In the commissioners' accounts, there is a note that in May 1795, there were twenty-two slaves and eighteen masons working at the Capitol with McDermott Roe. The contractor kept the lists of the hired slaves, so we don't know who they were. Collen Williamson remembered McDermott Roe's crew as "about thirty men beside negro's attending them."

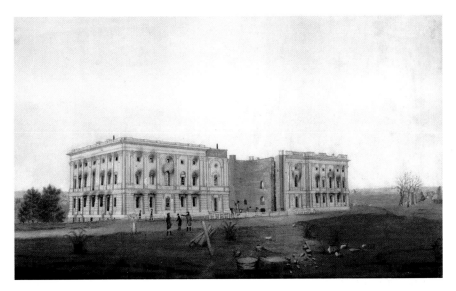

This 1814 painting by George Munger of the Capitol after it was burned by the British shows the early Capitol as a work in slow progress temporarily delayed. *From the Library of Congress.*

All seemed to go smoothly. The only hitch, judging by the commissioners' records, was the slow delivery of stone, which by that time was mostly the responsibility of Cooke and Brent and other contractors, and a lack of stonecutters to get the stone ready to set. McDermott Roe exaggerated the "days lost" by want of stone by multiplying the days lost by the number of his masons. His twenty-four men lost ninety-six days in May.

Another complaint from McDermott Roe suggested that he didn't know exactly what he was doing. He asked for proper directions in regard to the "thickness of each wall," where windows and doors were going to be as well as "what height the foundation is to run before free stone."

Then, in late June, at the peak of the building season as three hundred feet of smaller freestone was being laid on the foundation stone, almost all the walls collapsed.

The commissioners immediately put the best light on it. There were some bad foundation walls that could be removed and filled with "bond stone." Then the work could continue. The work at the North Wing could begin again in a week. On closer examination, it appeared that McDermott Roe's masons used no mortar or bad mortar and then filled gaps in the foundation with rubble. There was $1,264 worth of work that had to be replaced in the North Wing and $1,470 in the South Wing.

The commissioners fired McDermott Roe and ordered all those engaged with him to vacate their temporary lodging on Capitol Square within a week. The commissioners sued McDermott Roe for $1,253.33 in damages. He denied any responsibility.

The story is worth telling because, despite being closely associated with McDermott Roe's crew, the hired slaves were not used as scapegoats. The Irish masons did not blame them, and of course, neither did the commissioners, even though commissioners Johnson and Stuart, who had signed the piecework contract, had been replaced by new men.

Much to their embarrassment, the president thought the commissioners shared in the blame for the debacle. He authorized a $1,600-a-year salary for the commissioners on the condition that they would live in the city and keep a close eye on the work. However, the new commissioners lived in or near Georgetown. Secretary of State Edmund Randolph reminded them of that and implied that the bad work at the Capitol could have been prevented if they had been paying attention. The commissioners fired back, implying that the workers were too rude to be supervised by gentlemen. "Those not acquainted with the motley set we found here, and can form no adequate idea of the irksome scenes we are too frequently compelled to engage in."

One might describe slaves each with a different shade of dark skin as "motley," but the commissioners singled out Collen Williamson as especially irksome for always boasting about his "building castles" in Scotland.

The two new commissioners, Gustavus Scott and William Thornton, were both familiar with slavery. Forty-two-year-old Gustavus Scott, who replaced Johnson in 1794, was Virginia born. After an education in Scotland and London, he pursued a career typical of Maryland lawyers, making enough money professionally to support a plantation owner's lifestyle with eight children and twelve slaves. He hired out two slaves, Bob and Kit, to work for the commissioners.

Thirty-five-year-old William Thornton, also appointed in 1794, had won the design competition for the Capitol in 1793. Trained as a doctor in Scotland, he was better known as an Enlightenment-style polymath, a lifestyle supported by wealth derived from his family's plantations worked by slaves in Tortola, British West Indies, where he was born. He was the only commissioner not associated with the Potomac Company, but at least he grew up with slaves. He hired out one slave to work at the Capitol for three months.

Criticism from the president and secretary of state prompted the commissioners to question McDermott Roe's masons. As they built their

case against him, they also cleared masons who didn't seem involved in the shoddy work. They rehired them to work for wages, not by the piece. There is no evidence that they asked questions of the slaves who tended the masons.

The priority was to get work resumed on the Capitol. The commissioners had already backed off from finishing the Rotunda. Now they decided to stop work on the South Wing. They would finish the Senate Chamber in the North Wing and prepare a room above it where the House of Representatives could meet.

However, as designer of the Capitol, Commissioner Thornton thought hard on that. As

Commissioner William Thornton suggested training slave stonecutters but didn't press the issue and quickly adjusted to southern views of slavery. *From the Architect of the Capitol.*

McDermott Roe's complaints before the walls collapsed made clear, the limiting factor in the stone setting was the stonecutting. The stonecutters also received higher wages than any other workers. So a few weeks after the walls collapsed, Thornton wrote to his fellow commissioners suggesting that slaves were the solution to both the lack of and expense of stonecutters.

He suggested they "hire 50 intelligent negroes for six years," or better yet buy them, "as no interference of the owners could then take place." Two or three stonecutters paid over two times the going wage would train them. He warned that "if a measure of this kind be not pursued it is doubtful whether the building can be ready in the time required." The slaves could have their liberty "at the expiration of 5 or 6 years."

His fellow commissioners did not react. To buy fifty slaves could have cost $25,000, which would have swallowed up almost half their annual budget. Thornton's proposal would have likely demoralized the free workers they already had. The strife between Irish and Scottish workers was bad enough. When he made the proposal, he had only lived in the southern United States for less than a year. He quickly realized his idea was impossible. From his position of power, Thornton never proposed anything else for the benefit of slaves.

But Thornton's idea raises a question. Slaves cutting trees or hauling stones were doing familiar work. Did the slaves tending masons learn anything about setting stone? There is no evidence that the commissioners gave a thought to any of the slaves tending masons as individuals, and none were singled out and given more responsibility except when the commissioners had a hunch that strength and not skill was the key to getting a job done more cheaply.

As we shall see in the next chapter, slave laborers were given a chance to earn money for themselves if they sawed lumber. Evidently taking a hint from that, the commissioners tried to get slaves to saw stone. Thinner facing stones were cut to size with a large saw. It was slow and clumsy work, requiring the use of water to cool the thick blade. Paying stonecutters to do it was expensive

The commissioners first sent to Charleston, where there was reportedly a working stone-sawing machine. With one horse, one man could work four saws. In October 1796, a contractor tried to get it to work, but some brass fittings were wrong, and no one really knew how to run it. So the commissioners ordered their overseer, Bennett Mudd, to have "four negro laborers sawing freestone at President's house." They had no particular slaves in mind; any four would do. There are no payrolls in the records showing if any were employed or if they got extra wages like the slave sawyers got.

Working for the commissioners was not on-the-job training. But thanks to the recent efforts of Terry Buckalew to discover the lives of African Americans buried in a rediscovered graveyard in Philadelphia, we know what one slave hired by the commissioners did later in life. Joseph Beck of Prince George's County hired out his slave Ignatius to the commissioners in 1798. He was twenty-three or twenty-four years old at the time, and Beck's father had processed papers giving him his freedom when he was twenty-five. Once free, Beck moved to Philadelphia. He earned a living by making balls of shoe polish that were used by bootblacks. While he didn't practice a building trade, he did use his hands to make something.

The pace and pressures of raising the stone for the two largest buildings in the country probably precluded much on-the-job training.

Work got back to normal quickly. In October 1795, as masons set stone at the Capitol tended by roughly an equal number of laborers, Blagden, the head stonecutter, wanted to move some inferior stone away from the work site, but as he told the commissioners, he saw that he could not "muster a force sufficient without putting an entire stop to the setting."

In 1796, they upped the number of laborers they would try to hire from 100 to 120. Outlining the work program for the summer of 1797, Hadfield told the commissioners to hire "an additional number of laborers…as the setting of the stone and laying of brick will require more hands." Hadfield was raised in a British family with an antislavery view, but he needed good workers.

Hired slaves helped drive the work, and the higher the buildings got, the more demanding the work. Some payrolls during the peak of the summer building season seem astounding. Some stonecutters worked thirty-one and a half days. Evidently, in months with longer daylight hours, workers gained two hours a day credit for each day worked from dawn to dusk. If that were the case, six fourteen-hour days could be counted as seven twelve-hour days. Since the wage rate was by the day, that would seem fair and also give the workers an incentive to keep at it during those long days, which were the best days for building. Of course, the laborers tending other workers kept up the same pace.

Understanding the workers' payrolls in the National Archives is not easy. All workers had a wage rate by the day. In 1795, laborers were paid at a rate

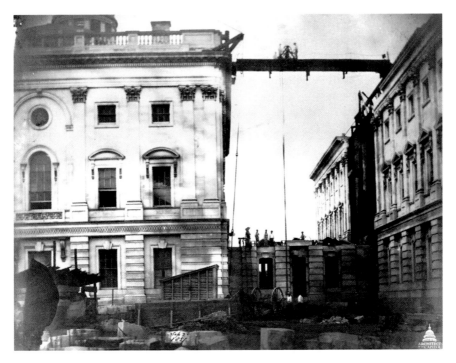

In 1857, workers connected the old North Wing of the Capitol to the new Senate Wing. The old Capitol was much smaller but, with less proficient cranes, more difficult to build. *From the Architect of the Capitol.*

of "sixty pence" a day, which translates to three shillings a day or about forty cents. Then, at the end of the month, their overseer multiplied the number of days worked by sixty pence. Laborers didn't seem to get a bonus for working fourteen-hour days. On the monthly payrolls, the hired slaves were marked as earning sixty pence times the number of days worked, but there is no evidence of those earnings each month affecting what their masters were paid on a quarterly basis—fifteen dollars in 1795. We best trust the commissioners' own statements as to what they paid as well as the consistent sums they sent masters rather than multiplying sixty pence by the number of days worked a year. For example, when sending an estimate of expenses for the year 1795 to the commissioners, James Hoban did not have to count days worked. He simply wrote, "For the hire of 100 Negros at 22 Pounds 10 Shillings per annum—2250 Pounds For the subsistence of said Negros at 12 Shillings per day each 1075."

As far as the slaves are concerned, more important than the numbers is the sudden disappearance of "Ns." Once the slaves principally tended masons, they were no longer labeled and placed at the bottom of payrolls. The overseers began putting the name of the slave's master right behind the slave's name. So Negro Peter who was owned by James B. Heard began to be listed as Peter Heard on the payroll. What distinguished slave laborers from free laborers who got the same wage was that the free laborers signed for their wages, usually with an "X."

In early listings of laborers, the free workers were listed first, followed by the slaves. But by 1798, there was no segregation of the names. Peter Short was listed above Peter Heard, and he was listed above Jacob Sampson, but Peter Short and Jacob Sampson were free workers. This suggests that, in the mind of the overseers, the races were integrated and that they worked together at the work sites.

At the same time, that we don't forget that hired slaves helped build the Capitol and White House, we might wish that during the subsequent troubled history of race relations in America, it was better known that black and white laborers working closely together built the Capitol and White House.

That said, sixty pence was a raise for laborers. They had been making forty-five pence a day through May 1795. So when free laborers, including Free Caesar, worked every day in a month, they got three pounds or almost $8.00. That suggests that slave hire was no longer checking the wages of free workers. But while the commissioners complained about what they had to pay free skilled workers, they never complained about the wages of free laborers. With one hundred slaves on hand, they could limit the number

of days free laborers worked and dismiss them as work wound down. They always felt in control as slaves kept free laborers' wages low enough and assured that they were getting as much productivity as possible out of the masons the laborers attended. The masons made eleven shillings a day, about $1.40.

The March 1797 payroll suggests the haphazard fashion in which the races came together to work at the Capitol. The slaves belonging to the two overseers, Samuel Smallwood and James Hollingshead, were working early in the month. Smallwood's Randolph and Daniel worked twenty-seven days. Hollingshead's John and Nace worked twenty. Two slaves from the nearby James Burnes family worked eighteen days. Free workers Peter Short and Joseph Howard worked sixteen days. Then fifteen laborers got on the payroll—only two were free. At the end of the month, seven free workers were hired, including Ambrose Moriarty.

In 1799, Moriarty wrote a letter to the commissioners saying he wanted to buy a building lot. He introduced himself by saying, "I have formerly been employed in attending masons and other work for the public." He did buy a lot and was on the city's 1803 tax roll.

Not many laborers wrote letters to the commissioners, and Moriarty's is important in two respects. If the hired slaves had been free workers and able to keep the five dollars a month they earned, they, too, could have bought something: their freedom and then a building lot. That Moriarty built a house on his lot suggests that he might have learned some building skills while tending masons and carpenters.

Unfortunately, in the minds of the commissioners, the status of the slaves was not elevated by working with whites. The status of the white laborers was lowered to that of a black slave.

As a December 1795 letter from the commissioners to the president shows, the commissioners always thought of their laborers as slaves. Facing a year-end shortage of money, they warned the president that they had to pay for the "quarterly hire of the black laborers." They worried "should the masters meet with difficulties in obtaining the wages of last year at the very moment we are advertising for 120 laborers for next year we shall certainly go into the market with bad grace." Of course, Captain Williams hired white laborers at the same time, including Ambrose Moriarty.

As that letter indicates, the major worry of the commissioners was raising money to pay their workers. They began relying on loans from the State of Maryland that were slow in coming. In 1797, they took advantage of frost to stop all work for the year on November 16.

The exterior stonework on both buildings was largely completed in the spring of 1798. Slaves no longer had to raise stone so high, but they still had to raise wooden timbers, including the ones they cut along Paint Branch. They were on the top of the world, briefly. The roofs done, the commissioners told Williams to hire only twenty-five laborers in 1799.

SAWYERS AND CARPENTERS

To tell the story of the slave sawyers who were instrumental in getting the roofs made, we have to go back almost to the beginning. In late November 1792, James Hoban noticed a slackening of work around him. Living on President's Square, nothing that happened around the site of the White House escaped his notice. He designed the building and was in charge of building it. He shared his dismay in a December 1 letter to the commissioners who had assembled for their monthly meeting.

"Our sawyers have dwindled a way from three pare, to two, from two to one pare, and now there is none," he wrote. "Mr Sandiford is now sick and his hands all dispersed, he has sent to inform me that he has got no hands, and intends to saw no more." An added pity was that the sawpit was "in complete order, and Sawyers can work to advantage in all weather."

Hoban's first order of business when he came to the city in the summer was to have a large hall with a wide nine-foot-high door built on the President's Square. There, he and a handful of carpenters he had brought from Charleston, South Carolina, where they had settled after leaving Dublin, Ireland, in 1787, would prepare window and door frames and flooring that would be needed after Collen Williamson's masons began laying stone. He wanted all the wood sawed in the winter so that it could season before being used at the end of the summer. He had the sawpit dug in that hall.

There was nothing fearsome about that pit. It was likely only four feet deep—not at all the size of a man's grave. The trestle above it was likely just five feet off the ground, accessible with a stepladder, and one could almost

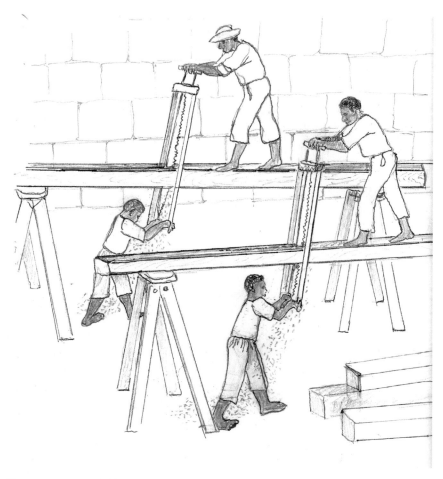

Slave sawyers earned thirteen cents a day, which they could keep themselves. In a city without lumberyards, their constant employment was essential. *Drawing by Leslie Kuter.*

jump down off it. What might prompt a man to dwindle away from the pit was the saw the pit was designed to accommodate.

The largest antique ripping saws on the market today are a little over four feet long and are designed for one man to use. One can buy a two-man crosscut saw that cuts trunks into logs, but a two-man ripping pit saw for cutting long boards is a very rare find. No one wants to use them. The man on the upper end of the saw has to walk backward on top of the tree trunk as it is being sawed, and the man on the bottom walks into a face full of sawdust. The biggest tree trunk two men might crosscut is smaller than the usual boards sawyers have to rip. For finer ripping, which sounds like a contradiction in

terms, the sawyers used slightly smaller saws, but they were just as heavy because they had wooden frames to make their cuts more accurate.

Most plantation owners had a slave carpenter or two they could brag on. Not for nothing were there no slave sawyers listed in plantation records. That was necessary work, but few men condemned themselves to the sawpit by calling themselves sawyers.

Using a suitably deferential, passive, conditional sentence, Hoban concluded his letter to the commissioners by suggesting, "It would be necessary to take some steps to get a Sett of Sawyers to be steady in this business."

The commissioners promptly put an ad in the local newspapers. At the same time, they had good news for Hoban. An American privateer had captured a French ship carrying mahogany. They wanted Hoban to go to Norfolk and buy the seized cargo. To add some panache to their ad, they gave readers a taste of elegance to come. Their ad solicited "four sets of sawyers with one set to be acquainted with sawing mahogany." The ad may have been talked about, but it didn't produce any sawyers.

Unfortunately, we have no idea if Sandiford's hands were slaves. That they simply left their work suggests they

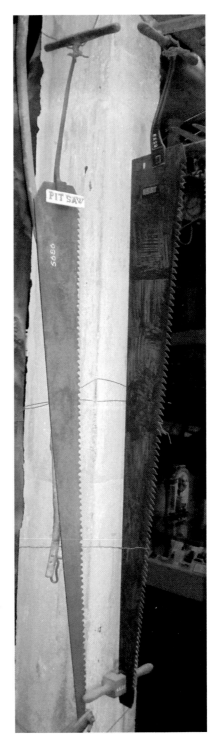

Old ripsaws that slaves mastered in sawpits are difficult to comprehend today. There is still a market for old saws but not old ripsaws. *Photo by Bob Arnebeck, from the Collection of the Mercer Museum of the Bucks County Historical Society.*

101

were free, but then, hired slaves traditionally went back to the plantations they came from before Christmas. The ad the commissioners placed didn't specifically solicit slave sawyers. Meanwhile, Hoban still needed sixty thousand feet of five- by one-and-a-half-inch plank.

We are not sure whom Hoban got to do that work in the sawpit. We know that in 1794, he owned four slaves. He may have brought them up from Charleston in 1792, but in the records we have, Peter, Daniel, Ben and Harry were never listed as sawyers, always as carpenters. The likeliest source of sawyers was from the workforce William Augustine Washington massed at White Oak Swamp in Westmoreland County, Virginia. He hired twenty-two hands whom the commissioners described as "laborers" and Washington described as "carpenters and axmen." At their February meeting, the commissioners asked him to send six of those laborers up to the city. They could have been carpenters who could handle a ripsaw.

But if those six slaves worked for Hoban, they did not solve his problem. In November 1793, the commissioners authorized him to write to South Carolina and see how much a wind-powered sawmill would cost and if men could be sent up to run it. But nothing came of that.

The commissioners placed their next ad in the fall of 1794, angling for sawyers to work through the winter just as Hoban wanted. They placed the ad in Baltimore and Easton, Maryland newspapers. A building boom was underway at the busy port city of Baltimore, and Easton, across the Chesapeake Bay, was a major source of lumber and slaves. The commissioners solicited "a number of slaves to labor in the brick yards, stone quarries & c for which generous wages will be given. Also sawyers to saw by the hundred [feet] or on wages by the month or year apply to Mr. Hoban." That is, they wanted sawyers to do piecework.

This ad may have gotten some results. At least two masters responded. On July 6, 1795, the commissioners paid $20.33 to a Caleb Varnal for his slaves on a piecework basis. That account notes that the contractor's "Negro sawyers" sawed 583 feet of oak. And on August 6, they paid $30.73 to Francis Hammersley for sawyers. (Judging from genealogical records, it appears that Varnals, or Varnells, did live around Baltimore. But the Hammersleys were in Charles County, Maryland, along the Potomac shore, and once owned the island across from Georgetown.)

Relying on one contractor in June and another in July evidently did not please Hoban, nor did sawing on a piecework basis, because he placed an ad in his name simply promising, "Three pairs of good sawyers will get constant employment."

James Hoban Jr. was said to have been the spitting image of his father, so this 1846 lithograph is our best portrait of the designer of the White House. *From the Library of Congress.*

The commissioners and, for that matter, President Washington wanted all work done on a piecework basis because that tied the cost of labor strictly to the work that had to be done. No one was paid while "skulking." Hoban knew that timber floated up or downriver did not always arrive when expected and masters would not hire out their slaves just when needed. He wanted sawyers ever at the ready, which meant offering them wages, not piecework.

Everyone else catered to the commissioners' system of bargaining with contractors and using cheap slave labor to force down wages or, better yet, force workers to do piecework. Hoban quietly bucked that system. We have to say "quietly" because all his personal papers were lost in a fire. He wrote frequently to the commissioners but rarely discussed his workforce, the management of which he thought his prerogative.

Hoban was an empire builder but was careful not to confront the commissioners. He was a leader of the local Masonic lodge and the militia, bought lots and built houses in the city. Indeed, he first lived on President's Square and lived the rest of his life in houses near the White House. He probably designed and supervised the construction of Blodget's huge hotel and at the same time built what he called the "Little Hotel," which proved much more serviceable. Most importantly, he fostered a network of carpenters and masons loyal to him. It might be going too far to say that he extended his empire to the hired slaves, but he did improve the working conditions of many of them.

Not knowing how many slaves Varnal and Hammersley had and how long they worked, we can't be sure if the commissioners were getting a good price. However, a slave sawyer could command a high price. In the commissioners' records, there is a unique payroll for sawyers working at the White House in August 1795 that probably marks the transition from paying contractors for sawing and using their own hired slaves.

A detail of a payroll showing Negro Simon receiving roughly thirty dollars for a month's worth of sawing, while other hired slaves earned four dollars. *From the National Archives.*

On top of the list is Negro Simon, who was paid seven shillings six pence a day, the same as an apprentice carpenter. He worked thirty days and made eleven pounds five shillings, just over half of what masters were getting for hiring out their slaves for a year. (It is unlikely that the slaves worked four Sundays that August. They probably worked all twenty-six workdays of the month and got credit for an extra day for each of the four full weeks of the month by working fourteen-hour days.) It's possible that "Negro Simon" was actually a freeman and kept that money. But he was paid what Hammersley was paid for work in July, so perhaps he was Hammersley's slave.

Then the payroll lists seven of the commissioners' hired slaves—Jerry, Jess, Charles, Len, Bill, Dick and Jim—each paid one shilling a day and working for thirty days.

In his 1792 work plans, L'Enfant listed sawyers, and he budgeted paying them ten dollars a month, more than laborers at seven dollars and less than carpenters at twelve dollars, but that was a plan and did not solve the problem of finding sawyers. Hoban found the solution by finding slaves whom the commissioners had already hired who knew how to handle a ripsaw. He found them out by tapping into the tradition of paying slaves "extra wages."

The work schedule for free workers and slaves was the same—dawn to dusk six days a week. All had Sunday off, but by custom, if a hired slave worked on Sunday or a holiday, he had to be paid extra wages, which meant the money was his to keep, not the master's. He signed his "X" and earned a shilling or about thirteen cents. The commissioners were reluctant to send slaves out on the river to avoid having to pay slave members of the crew a shilling if the boat was out through Sunday. Because there were many Catholics in the area, the two days after Easter were considered holidays, and in 1796, when three hired slaves, Charles, Harry and Charley, attended two carpenters on the Monday and Tuesday after Easter, Hoban paid them three shillings and nine pence for each day in extra wages.

So Hoban induced slave laborers to become sawyers by giving them an extra wage of a shilling a day. Negro Simon is not on any more payrolls, and suddenly there was no shortage of slave sawyers. There were crews at both buildings. The September 1795 payroll for sawyers at the Capitol lists six slaves getting a shilling a day: Ben, Alick, William, Thomas, William and James. Useful as a second name might have been to distinguish the two Williams, slaves in the commissioners' records never had a second name and were so distinguished by noting their masters' names. There was no need to note the master on this payroll because the slaves took the money. The money paid to the Williams stayed with the Williams.

The slave's shilling a day added to the two shillings and six pence a day their masters were getting meant the commissioners were paying three shillings and six pence for their sawing and thus got a good deal. Their slave sawyers cost just under half of what Negro Simon cost them.

There is no evidence of compulsion. The slaves were not whipped into getting a shilling a day. Hoban's ads promising "constant employment," something slave masters, including the commissioners, always cherished, suggests that the sawyers were pressed to do work at a pace not worth a shilling a day even to a slave. However, an August 1798 payroll listing fifteen slave sawyers at the Capitol shows that work was not constant. Moses, Alick, Davy and Sill worked all twenty-seven working days that month. Jess worked twenty days. Clem and Billy worked seventeen days. Dick, Tony, Oliver and Moses worked sixteen days. George worked fifteen days, Sam thirteen and Stephen and Perry two days. Perhaps Stephen and Perry gave it a try, wouldn't do or didn't like it and returned to the pool of laborers—roughly forty-two men working at the Capitol in the summers of 1797 and 1798, mostly tending masons or the carpenters.

In March 1796, in an effort to persuade Congress to appropriate money for building the White House and Capitol, the commissioners sent a list of the month's labor expenses at both buildings. "Negro sawyers" topped the list at the President's House, though in calculating that expense and what they paid for laborers, the commissioners didn't include the sixty dollars a year paid to slave masters:

PRESIDENT'S HOUSE
Negro sawyers $15.86
Stonecutters $387.91
Carpenters $417.20
Overseers & Laborers $33.71

The commissioners seemed proud of finally answering Hoban's suggestion to use the winter to get materials ready for the spring.

In 1797 and 1798, as carpenters framed and built the roofs of the two huge buildings, the sawyers became even more essential. No one had ever built roofs that big in America. Hoban and Hadfield had differences about how it should be designed and done. In February 1798, a dramatic scene played out either in the so-called carpenter's hall (everyone other than the commissioners called it a shed) or inside the Capitol, where there was plenty of space for temporary sawpits.

As the sawyers worked in the sawpit, twenty-one carpenters prepared the roof for rafters, working under the supervision of Redmond Purcell, who came from Ireland with Hoban. He tried to prove to the commissioners that the Englishman Hadfield was incompetent, which would have left Hoban the only man in town qualified to supervise construction at the Capitol. He sent the commissioners descriptions of Hadfield's inability to make drawings the carpenters could use. He left us some vivid writing, and twelve hired slave sawyers were his witnesses. A well-sharpened ripsaw "sings" as it cuts through wood, but the slaves probably heard every word and those words probably got around:

> *The sawyers at this time being nearly at a stand, I had to again request another sketch. The stuff for his former sketches being all prepared.—We went to the sawpit, and there I explained to him how the business stood,—that the carpenters would be idle in a short time, as also the sawyers in a few hours. That I really was at a loss how to proceed. His answer was to get some of the pine and have it sawed for small rafters. I told him that would be the last that would be wanted for the roof.*

A month later, Purcell told the commissioners that, flummoxed again over the size of boards needed, Hadfield stopped the sawyers, and in turn, Purcell had to stop the carpenters because they had no boards. Hadfield quit. Of course, the commissioners fired Purcell. Such insolence could not be tolerated.

Although they seemed blameless, reverberations from that feud soon meant changes for the slave sawyers, but to understand that story, we have to tell another: how Hoban tried and failed to establish slave carpenters as part of the crews of skilled workers at both buildings.

In 1796, when Hoban made a list of workers needed to finish the White House, he listed "Negro carpenters" as well as sawyers. The commissioners didn't seem to notice, though they should have known that Hoban had slave carpenters. Back in 1792, the commissioners and the president thought one of the attractions for hiring Hoban was his promise to bring a crew of workmen with him from Charleston. Why should anyone be surprised that his crew included slaves?

President Washington may have been under the impression that the commissioners hired slave carpenters. In 1793, he wrote to his nephew asking if he had any "Negro carpenters" to hire out for work to be done at Mount Vernon. His nephew replied that he thought all the available slave carpenters had been hired to work in the federal city. There was very little private building in the city in the winter of 1793, so the president probably assumed that the slave carpenters were working for his commissioners.

The payrolls for carpenters from December 1794 through November 1797 list slaves and indentured servants owned by Hoban and another carpenter who came with him from Charleston, Peirce Purcell. Hoban's Peter and Peirce Purcell's Tom were generally paid a shilling or two a day less than free white carpenters. Three of Hoban's slaves, Ben, Daniel and Harry, made the same wage as teenage boys who worked with the carpenters, a shilling and a half more than the hired laborers. Boys learning a trade, indentured or free, often sons of the carpenters, were commonly employed in work crews everywhere. That's how skills were passed on. Of course, all those wages were collected by masters or fathers. Two slaves owned by Purcell, Tony and James, worked at the Capitol along with Hoban's Harry.

If Hoban had hired slave carpenters from masters other than himself and his crony, we could conclude that his goal was to get skilled carpenters at a slightly lower wage. But Hoban supplemented his $1,500 salary with money that his slaves and indentured servants earned, often to the tune of $700 a year. Purcell made twenty shillings a day. He could add more to that by

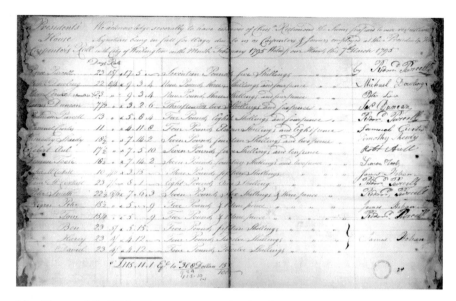

Monthly payroll for White House carpenters showing that James Hoban received the wages of his four slaves, Peter, Ben, Harry and Daniel. *From the National Archives.*

keeping his slaves on the job, a decision entirely up to him and Hoban. Both men were single and likely easily shared food and living space with their slaves as well as indentured servants.

Were their slaves' skilled hands contributing to the work, or were Hoban and Purcell padding their salaries?

Hoban's Peter and Purcell's Tom could have been excellent carpenters. That slaves were not paid was not necessarily a reason for them to do bad work. Their skill kept them from being sold and perhaps forced to do less congenial work. Slaves also developed loyalties to their masters, and we can imagine that being owned by such important men gave them status among both fellow slaves and whites.

On the other hand, Hoban had to have had a sense of being underpaid. Architect builders were trying to establish a custom that they get paid a percentage of all the money spent on what they built. Hoban likely felt entitled to increase his salary by every means he could. He certainly was more essential to the project than the commissioners, who got $100 more a year than he did and hired their own slaves.

That free carpenters objected to Hoban's slaves doing work they could have been hired to do doesn't reflect on the skills of the slaves. Not surprisingly, some free workers dismissed the skills of slaves. Collen

Williamson, who blamed Hoban for getting him fired, vituperated in a letter to President Adams that Hoban and Purcell "have among them ten or twelve negro apprentices and drawing wages for them. Six of them is not equale to one good hand."

But the commissioners had no respect for Williamson's opinions. He wrote harsh words about them, too. As a matter of policy, it would seem the commissioners would welcome slave carpenters, who were always paid a shilling or two less a day than free workers. But that was the rub: as noted in an earlier chapter, they certainly were shocked when the contractor James Clagett billed them for the wages of two slaves who were paid at the same rate as two free workers.

Anyway, on November 15, 1797, without any recorded discussion or explanation, the commissioners "ordered that after the expiration of the present month no Negro Carpenters or apprentices be hired at either of the public Buildings." They made the order before Williamson wrote his letter to the president, so we can't say the commissioners were trying to accommodate President John Adams, who they had to assume had a far different view of slavery than his predecessor. (There is no record of Adams expressing any opinions on slavery while president. Support of southern states was crucial for his election and reelection.)

Hoban did not protest the order, nor had he ever presented reasons to the commissioners for hiring slave carpenters. We'll probably never know why, but there are three explanations for why the order was made and not protested.

At the end of 1795, the commissioners feared not being able to pay workers and slave masters. In November 1797, they had not paid their workers since September. With funds so scarce, Hoban's padding his salary thanks to his slaves' work may have angered free workers.

The nature of the carpentry work was changing. Judging from the payrolls we have, there was not much carpentry work to do at either building until 1797. In December 1794, there were eleven carpenters working at the White House under Peirce Purcell along with three apprentices and five slaves. In 1795 and 1796, the carpentry crews in both the White House and Capitol were smaller, around seven or eight men, but always supplemented by five slaves at the White House and two at the Capitol.

In February 1797, with the Capitol's second story completed, there were twenty carpenters. In 1800, with the deadline for finishing the building imminent, there were thirty-two carpenters at the White House. Nine of the carpenters worked thirty-one and a half days, which suggests that they worked such long hours six days a week that they were credited with four

and a half extra days. Of course, slaves were practiced at being forced to work such long hours. But hired as carpenters, would they have worked such long hours without extra wages they could keep? The sawyers who prepared lumber for them were getting extra wages.

Finally, would masters send slave carpenters to the city? Could the commissioners expect that there would be slave carpenters available when they were needed?

In 1798, George Washington, then retired, made a contract for building a double house just northwest of the Capitol that would board congressmen. Commissioner Thornton mediated between Washington and a contractor. To save as much money as possible, Washington had Thornton tell the contractor that he would send his own slaves to the city to do the carpentry work on the houses, but he never sent his slaves. He worried about who would watch and feed them, despite two of Martha's granddaughters living in the city both married to wealthy men and one owning many slaves. Obviously, Washington worried that they had to be watched closely. Slaves who could show they had marketable skills might run away.

Meanwhile, since 1792, there had never been a shortage of free carpenters in the city ready to be hired.

As for Hoban's Peter, it's easy to imagine Peter continuing to do work for Hoban and sharing his intimate knowledge of the White House with the many newly hired carpenters. Hoban personally had a lot riding on getting the building satisfactorily completed. He would have profited from Peter's experience even if he wasn't getting paid for it. We know that Peirce Purcell didn't sell Tom. After being fired from the public works, Purcell built private homes.

The task that changed the carpentry crew from Irish friends of Hoban and his slaves and apprentices into a large crew of men best described as possessed was the hard work of framing and making the roofs of the White House and then the Capitol, the former in 1797 and the latter in 1798. This was work on a scale that had not been attempted on American soil. Free carpenters complained to the commissioners that they had to buy new tools, that they were forced to work in the cold and, if that wasn't enough reason for a raise, it "required great attention to keep all the laborers at work."

And all the laborers, slave and free, were at their side save for the slave sawyers, who were sawing the boards the carpenters needed on demand. The first job was to level enough ground adjacent to the buildings and position the roof timbers and rafters on the ground to, in a sense, rehearse the big show on top of the buildings. Then the cranes and attendant men and horses had their last challenge, and then the laborers and carpenters

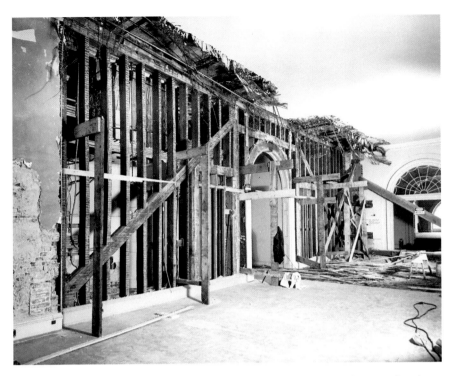

A photo by Abbie Rowe of the 1949 renovation of White House shows the type of work carpenters, including slaves, did in the 1790s. *From the National Archives, Truman Museum.*

squared the oak timbers fifty-two feet long. Some of the slave laborers who had gotten the timbers into the Paint Branch back in the winter might have given the carpenters some confidence.

When Niemcewicz visited the Capitol in late May 1798, he went up on the roof and was puzzled that all the men there worked in complete silence. But that was back when Hadfield and Purcell were feuding. Then Hoban took over. There is no evidence that he paid extra wages to the hired slaves, but we know from the commissioners' records that he ordered that men working on the roof of the Capitol get half a pint of whiskey per day and, on hot days, a small portion of spirits and water half a day.

Despite the demands of the work and the approaching deadline to get the buildings ready by the summer of 1800, once the roofs were in place, the commissioners decided to fire Hoban. After the commissioners, he was the only highly paid employee. However, he was so identified with the work at both buildings, annually writing progress reports that were forwarded to Congress, that the commissioners decided they had better find reasons to fire him.

By April 1799, the commissioners had a file of complaints, unfortunately no longer in their records, giving them cause to give Hoban notice. They told Hoban "that fourteen carpenters for a period of seven weeks or more, did not do one third of the work justly to be expected from them, that thirteen sawyers for a whole year played the same game." That should have "attracted the attention of the Superintendent [Hoban] and ought to have been noticed and redressed by him and we are inclined to believe, the world will say by the commissioners also."

There is a letter in the commissioners' records that seems to support their charges. In response to their questions, one carpenter wrote to them, "Gentlemen, I acknowledge that there might [have] been more work done than was but it was so general that every man in the yard took whatever Liberty almost he pleased as the main thing was to keep time." But in that same letter, the carpenter begged to get his job back, which may have prompted him to tell the commissioners what they wanted to hear.

Hoban had no friend on the board. Commissioner Carroll, who had been on the board that hired him, had long since retired and died in 1796. Alexander White, a retired Virginia congressman appointed to replace Carroll, had been admonished by President Washington "to have an eye that the over lookers of them [the workers] are diligent." Commissioner Scott supported any move that saved money. Commissioner Thornton had always been eager to remove men who were architects and who might alter his design of the Capitol.

As it turned out, Hoban hardly missed a day's work. Thornton evidently hoped that the building had progressed far enough that workmen no longer needed drawings. But he was wrong. The other two commissioners became exasperated by Thornton's inability to make drawings requested by workers for a building he supposedly designed. Hoban was promptly rehired.

However, the commissioners did manage to get rid of the sawyers who allegedly had loafed for a year. But the commissioners got them off their payroll in a way that redounded to the credit of the sawyers. The commissioners hired out the sawyers to contractors for sixteen dollars a month. The sawyers only cost the commissioners six dollars a month.

The commissioners trusted that they could get all the lumber they needed from plantations rich in pine trees on Maryland's Eastern Shore near Salisbury and Snow Hill. However, the scantling they ordered, small boards for studs and lathing that are the "Is" and "Es" of carpentry, didn't work out so well. Their carpenters rejected most of the first shipment of scantling, but the commissioners pressed for more, claiming that if it didn't arrive in two

or three weeks, "the Capitol will be delayed." Soon, the commissioners hired their slave sawyers back from the contractors.

John Templeman had hired seven of them, and judging from a payroll in the commissioners' records, he only gave them back on condition that the commissioners pay the sawyers extra wages of a shilling a day for the time the sawyers worked for Templeman. Evidently, Templeman did not want the slaves cheated out of the pittance the commissioners had been paying to them for four years.

It's unfortunate that men who worked so hard got paid so little while their masters and the commissioners profited. Sawing wood could have been a road to freedom for slaves. If paid fairly, they could have saved enough to buy their freedom. There was a model for such a process always in view as the city was being built. In Maryland, African Americans dominated the brick-making trade, and the commissioners and the private builders who came to the city needed millions of bricks.

Bricks

In September 1791, the commissioners ordered L'Enfant to have enough clay dug up to make three million bricks. No building block of a city was so readily available. Clay could be found on Capitol Hill and the President's Square, and there was ample wood to burn brick kilns. The commissioners were told that it was best to let the piles of clay freeze and thaw for a winter or two, which is why it was important for L'Enfant to get it dug up as soon as possible. Perhaps worried that the commissioners were going to force him to make the President's House and Capitol out of brick, L'Enfant ignored that order.

Before the commissioners hired Collen Williamson or James Hoban, they tried to hire a master brick maker. In November 1791, when Francis Cabot, a Yankee merchant, left Georgetown for home, the commissioners asked him when in Philadelphia "to enquire on what terms we could get some of the most experienced brick makers to come here early in the spring." But the report Cabot sent back made brick makers seem pretty expensive. Plus stone buildings won the design contests for the public buildings.

So the commissioners didn't hire a brick maker and relied on contractors to make the bricks they would need. There is evidence that the first man the commissioners bought bricks from, William Hill, was a free black. The commissioners paid him for making 180,000 bricks at the President's Square in May 1792. In the records of the Maryland Jesuits, there is a 1760 agreement between George Hunt S.J. and William Hill, "a Negro bricklayer," for work at St. Thomas Manor in Chapel Point, Maryland, soon

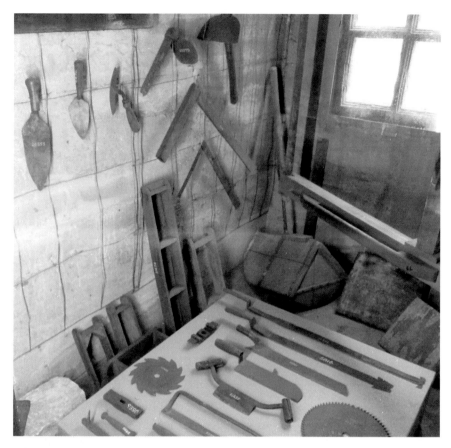

Brick-making tools that African Americans must have known well since they dominated the trade in Maryland. *Photo by Bob Arnebeck, from the Collection of the Mercer Museum of the Bucks County Historical Society.*

to be called Port Tobacco, in Charles County, Maryland, not far from the plantation homes of many of the slaves the commissioners hired. In 1790, William Hill was listed as a free black living in Port Tobacco, in a household of eight free blacks and two slaves.

With so many bricks to be made, brick making should have been the job at which African Americans made some real money. Hill appears to have won his freedom and gained wider experience in his trade between 1760 and 1792. In Maryland in the 1790s, most workers in the brick-making business were African Americans. Irish canal diggers didn't dig clay. The commissioners got Middleton Belt and Bennett Fenwick to do that, not Patrick Whalen. Both Belt and Fenwick used slaves. To get hands to make

bricks for the canal around Great Falls, an ad asked for "Likely Negro Fellows." In 1798, a petition in Baltimore began with the premise that there were four black men for one white man in the brickyards of the city.

But the commissioners stopped buying bricks from William Hill. In 1792, when their master stonemason, Collen Williamson, was still in their good graces, he persuaded them to make the first floor of the White House entirely of stone like the castles in Scotland he had worked on. He didn't want any bricks in the building.

Of course, the constant headaches of getting stone from Aquia Creek and other quarries soon convinced the commissioners that they had to use bricks, too, despite Williamson's opinions. The head mason at the Potomac Company explained to Commissioner Johnson that even in a stone building "the inner Part of the Walls [are] of common Brick." That was "a common Way of building the best Houses in Ireland and in England." Hoban wanted bricks to secure the interior of the buildings. The outside would be stone, which suggested that the bricks did not have to be of the highest quality.

Meanwhile, in the summer of 1792, the commissioners had learned the virtue of hiring slaves. In 1793 and 1794, with the help of Robert Brent, they

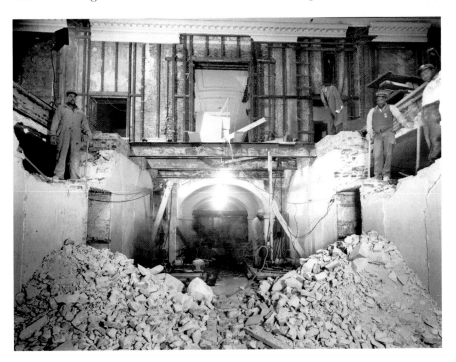

The 1949 renovation of the White House revealed the many bricks used in the building that otherwise were never seen. *Photo by Abbie Rowe, from the National Archives.*

tried to increase the number of slaves working in the quarries. In 1794, their enthusiasm for hired slaves probably inspired the Georgetown merchant John Mitchell to make a contract to supply the commissioners with one million bricks. His business plan must have pleased the commissioners. He would hire slave laborers to do the work on exactly the same terms as the commissioners hired theirs.

As we'll see from his letters, Mitchell was a bit larger than life, but he is still hard to place. According to the 1790 census, there was a Captain John Mitchell in Georgetown in a household of four white adults and seventeen slaves. So he was a man of substance. The slave who ran away in 1793 while working for the commissioners was Mitchell's. But there was also a Captain John Mitchell in the Charles County census with twenty-two slaves. That's the county where the commissioners hired many of their slaves. It's possible they were the same man. In 1794, a Captain Mitchell's ship took President Washington's new overseer, a Scottish immigrant, from Philadelphia to Mount Vernon. The ship was probably on its way to Georgetown.

Judging from the letters Mitchell wrote to the commissioners, he stood toe to toe with them. His letters were frank, even confidential, certainly befitting a man who had a command of the Potomac River and who was known and respected by the president. Mitchell seemed just the man to get bricks made by hired slaves at the low prices the slave-owning commissioners expected. He had already sold barrels of Indian meal and pork to the commissioners, food for the commissioners' slaves.

In December and January, at about the same time Cooke and Brent were advertising for sixty slaves and the commissioners for seventy, Mitchell announced in his advertisement, "I want to hire 40 Negro men until Xmas next."

That there were slaves in the area who could make bricks was obvious. Yarrow, the famous Georgetown slave, was a brick maker. But more to the point, plantation slaves were born and bred to the trade. The tradition probably began in England, which has the best brick buildings. In his drawings of rural occupation in early nineteenth-century England, W.H. Pyne depicts men loading clay on tables, women molding it into bricks and children carrying the bricks to dry in the sun prior to their being baked in a kiln. In the South, slave families did that. We should add that as a special occasion in rural life, brick making was probably fun. Compared to rock quarrying and lumbering, there was less threat of physical injury and much less physical exertion. Mixing clay in pits made lovely mud puddles for children to play in. Watching brick kilns through the night must have been conducive to storytelling.

In the eighteenth and nineteenth centuries, rural families in England and slave families in America made bricks. *Drawing by W.H. Pyne, Dover Books.*

We have no sure evidence that Carroll families used their own slaves to make the many bricks they needed to build their houses, but it seems likely. Before there was an influx of workers drawn to build the city of Washington, Daniel Carroll of Duddington had amassed a large number of bricks for his house. Of course, L'Enfant had his men stop that work in late 1791. Young Carroll was playing catch-up in the brick-building field. His uncle Notley Young's manor house was made of brick. His mother's slaves lived in what one critic called brick hovels.

If slave brick makers were on nearby plantations, there must have been many more on faraway plantations. We know for certain that the kitchen at Resurrection Plantation was made of bricks since it stood long enough to be photographed. So the St. Mary's County slaves might be good brick makers too.

Of course, the trouble with Mitchell's business plan was that African Americans both slave and free knew the business. No one quite knew how slave laborers would fit into building huge stone buildings; making bricks was another matter entirely.

A 1799 ad placed by a contractor building John Tayloe's Octagon house just southwest of the White House shows a good deal more sophistication than Mitchell's ad. The contractors wanted "Negro's that have been used to the Bricklaying business, amongst which must be four good molders, temperers, & boys as off-bearers for which generous wages will be given." Temperers kept adding water to the clay to keep it at the right consistency for molding into a brick. By saying "for which" and not "to which" suggests that the ad solicited

slaves. "Generous wages" suggests that masters would be paid more than they would get for hiring out slaves to the commissioners. The use of slave "boys as off-bearers" raised no eyebrows then nor should it now. According to a 1793 description of brick making in New England, boys did it there too.

Unfortunately, we don't know who was hired by Tayloe's contractor or by Mitchell. Judging from his letters to the commissioners, Mitchell had trouble getting the slaves he wanted. Of course, contractors are prone to complain, but Mitchell's frank letters suggest that the slaves or free blacks he had to hire were not the docile, versatile and cheap sort he needed.

He wasn't even able to hire enough slave laborers to get his operation going, so on February 11, 1795, he asked the commissioners for "seven of your negroes." The commissioners sent slaves they had hired from St. Mary's County, probably slaves they hired from Edmund Plowden. After a short trial, Mitchell sent them back, and he complained, "It's probable gentlemen you have not an idea of the expense I am at for proper labor's after I found the negro's I hired from St. Marys would not answer."

It seems that hired slaves were not so easy to exploit in the brick-making business. Slaves the commissioners hired who, as the records show, filled other jobs satisfactorily "would not answer." Mitchell was forced to hire more expensive workers.

One "laborer" came from Colonel William Deakins, a Georgetown merchant and the commissioners' treasurer. That man cost Mitchell "nearly 20 dollars per month." He had to feed him and give him "a half pint of rum per day…& I can have him no longer then the present month." Wages like that threw off Mitchell's business plan that was based on paying masters sixty dollars a year for slaves.

That Yankee merchant who had scouted brick makers in Philadelphia for the commissioners had reported that for an "overseer of the burning" a good man could be had for sixteen pounds, about forty dollars a month; molders for twenty dollars a month; and "the rest of the business is conducted by common laborers." So perhaps Deakins's laborer was a molder.

Was he a slave? Deakins, a genial elderly bachelor, owned eight slaves in 1790. But as a director of the Potomac Company, he had recruited indentured servants and free workers for work on the canals. Mitchell's letter suggests that he paid Deakins the wages, which suggests that the man doing the work was a slave. But that slave certainly had leverage over Mitchell and probably enjoyed his rum.

Another letter suggests that Mitchell paid some of his workers directly. In August 1795, Mitchell complained about not being paid for his first kiln of bricks.

Bricks kilns often glowed in the night along Pennsylvania Avenue. No artist tried to draw them. This kiln was in England. *Drawing by W.H. Pyne, Dover Books.*

Each delivery was called a kiln because thousands of bricks were baked at once. The commissioners' hired slaves had taken the bricks from the kiln up to the President's Square, but the overseer Hardman, who was supposed to count them, was three miles away getting sand. Hoban used the bricks for a building to house workers. Then the commissioners refused to pay him for bricks that had not been counted. "To obviate that & every other difficulty," Mitchell offered to knock ten thousand off the number Hoban contracted for, and for that number Mitchell had to be paid, "for I must pay my brick makers."

Since he did not say pay "for" his brick makers, that suggests he was not using hired slaves in all facets of his operations. It suggests that he was paying free workers by the kiln or month and not paying distant slave masters quarterly payments for slaves hired for the year.

As it turned out, Mitchell didn't work those slaves he might have hired until Christmas. In October, he reported that his "people" were so sick with "ague and fever, intermitting fever, & laxes" that he dismissed them. This was the nadir for any slave forced to work in the city. After burning bricks near the President's Square, he had moved his operation just west of Capitol Hill just above low marshy ground. Water for working the clay was nearby, but so were mosquitoes. Clay pits helped them breed. Mitchell's writing "people" and not "men" suggests that boys were working too, which is not a pleasant picture. The "people" may have been his own slaves, but would he say "dismiss" when referring to his own slaves? Mitchell later complained of

ill health and blamed brick making for it. So at least he suffered along with his workers.

Despite stopping work two months early in 1795, Mitchell was adamant in his approach, trying to hire forty slaves again as cheaply as possible in 1796. The commissioners boasted that their hiring slaves checked the demands of free workers. Mitchell's letters give the impression that he was trying but failing to check the demands of skilled slaves being hired out by shrewd merchants like Deakins and check the demands of free black brick makers.

What other information we can glean about brick making in the city comes from the records of private builders. A syndicate of three northern speculators, James Greenleaf, Robert Morris and John Nicholson, got a good price from the commissioners for six thousand building lots on condition that they build at least ten good brick houses a year.

Morris was the most famous of the speculators, famed as the financier of the American Revolution. But in 1794, Greenleaf had the most cash on hand and directed their operations in the city. Only twenty-eight years old in 1793, he had dazzled Europe and America by making huge profits when speculating with Dutch banks on the American Revolutionary War debt.

Greenleaf took a personal interest in brick making. To celebrate the infusion of money into the city and the prospect of accelerated public and private building, the commissioners placed an ad in Philadelphia and New York papers soliciting "A great number of mechanicks in the building line, especially Brick-makers, who will be able to carry on their business on a large Scale." Greenleaf paid for the ad to run in New England, too.

Then he bought a newly invented brick-making machine, hired the inventor, Apollos Kinsley, and sent both to Washington. The patent model and drawing for the machine were lost when the British burned Washington in 1814. Judging from a 1793 letter Kinsley wrote to Thomas Jefferson, who administered the patent office, the virtue of the machine was that it mechanically pushed clay into molds at a higher rate than skilled hands could. If that's so, then the machine eliminated the skilled men in the operation.

Once set up at Greenleaf's Point, the area a mile southwest of the Capitol where Greenleaf centered his operation, the brick machine attracted such a crowd that a fence was built around it. After all, it was expected to make two or three million bricks in a matter of days. Eventually, there were four brick-making machines in the city.

Stones in the clay broke the machine's cutters, forcing constant repairs, so the brick machines did not live up to expectations, which was good news for African Americans because they were needed as molders. Kinsley left the

All the larger private houses in the city were made of brick. Wheat Row on Fourth Street Southwest still stands. Whether a brick machine, free blacks or hired slaves made the bricks is unknown. *From the Library of Congress.*

city in 1795, but he evidently left his brick machine behind for the commissioners to lend to contractors. In 1798, they paid a man for twenty-three and a half days of hauling a "brick mashean" at the Capitol.

We can judge the relative success of the brick machine in an odd way. At the end of 1795, work in Washington drove one of Greenleaf's building contractors insane, and his wife wrote to Greenleaf cursing the day she and her husband were lured to live and work in the new city. Isabella Clark didn't

stint on the colorful language when describing her neighbors all trying to cash in on Greenleaf's building projects: "Miscreant Junto of Gipsies, French Poltroons, Dolts, delvers, Magicians, Soothayers, Quacks, Bankrupts, Puffs, Speculators, Monopolisers, Extortioners, Traitors, Petit foggy Lawyers, Ham Brickmakers, and apostate Waggon Makers."

She didn't forget the African Americans on the scene. They were the "Ham Brickmakers." That suggests that those supposedly black and enslaved because of Noah's curse on his son Ham made more bricks for the contractors than the brick machines. But her colorful description doesn't help us distinguish between slave and free brick makers.

Another of the three speculators, John Nicholson, tried to finance the syndicate's building in the city when Greenleaf withdrew. Nicholson was reputed to be able to write two letters at once using both hands. His contractors certainly wrote many letters back to him, generally begging for the money he promised.

His approach to city building was akin to colonization. He set up a company store and negotiated contracts with workers so that a good part of their wages amounted to goods they got at the store as well as in building lots and materials to build houses. Nicholson counted on his workers becoming a part of the city.

Nicholson's first storekeeper, Lewis Deblois, bragged that he had a "Philadelphia brick maker…making what people say are the best bricks in town." That brick maker was likely Jeremiah Kale. The commissioners almost hired him in early 1793 for fifty dollars a month. On July 22, 1795, Deblois wrote that he had "5 gangs making bricks on the spot at 10 to 12,000 a day in good weather." It was said that a good molder could make two thousand bricks a day. Evidently, they all worked under the supervision of Kale.

The "gangs" can easily be pictured as hired slaves, although in the many letters to Nicholson from his contractors begging for money to keep up their operations, there is no mention of hiring slaves. First Deblois wrote that his "master brick maker threatens he will not wait for his money longer than next week." Then a few weeks later, Deblois wrote that "7 brick makers had left me—by borrowing money and making part payments I have got them all at work again." There is no mention of paying slave masters, which suggests that the seven brick makers were free.

However, Deblois doesn't mention paying the laborers who made up the "gangs." For contractors, one virtue of slave hire was that masters were accustomed to getting paid quarterly or even at the end of the year. Nicholson's next storekeeper reported that he had to pay 120 workers

every week. Given Nicholson's growing reputation for not paying up, many workers demanded a day's wage in advance. Those men were probably not slaves. Those who did the brick making could have been free blacks.

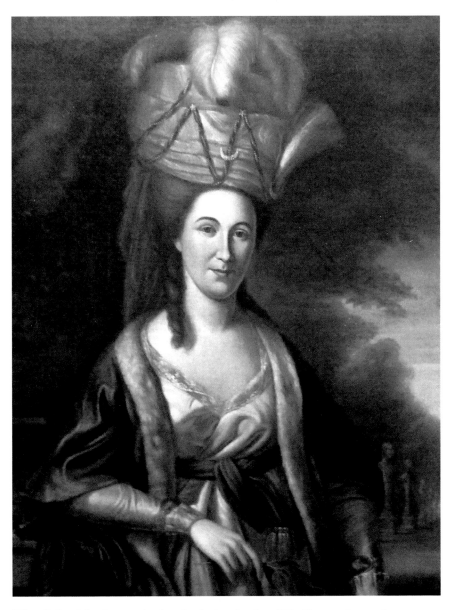

When Robert Morris committed to developing the city of Washington, free workers were attracted to the city. They trusted a speculator who could support his wife with such opulence. *Portrait by C.W. Peale, from the National Park Service.*

This is not to suggest that the northern speculators were averse to slavery. They bought or hired slave servants when they came to the city, and one of the first buildings Greenleaf had built consisted only of planks nailed onto trees standing in the middle of a yet-to-be-opened street. It was likely a place for hired slaves to bed down. Once the speculators went bankrupt, several of their unfinished brick buildings were occupied by free blacks. There would be some justice in that if those free blacks were unpaid brick makers and their families, but there is no record of anyone asking who they were.

However, thanks to the stature of the third member of the syndicate, there may have been a good number of free white laborers looking for work in the city. Robert Morris, Maryland born but long a resident of Philadelphia, was a national icon famed as the richest man in the country. The president in Philadelphia lived in a house rented by Morris, while a few blocks to the west, L'Enfant built a huge mansion to be Morris's palace. Morris came to the city for a brief stay and said he planned to put his son in charge of his Washington operations. But before he could fairly get started, he, Greenleaf and Nicholson went bankrupt, leaving at least one hundred men, many experienced construction workers, without jobs and with no likelihood of getting paid for past work. When added together, the three speculators' debts amounted to more than $12 million.

However, we really can't say that because free African Americans had a foothold in the business and many free workers were desperate for work, all brick makers were not slaves. Sometime slave dealer Bennett Fenwick used Mitchell's business plan with a twist. He would also buy slaves to make bricks. In 1800, he advertised to buy or hire ten or fifteen "slave men" and five boys ages fourteen to seventeen.

But Jeremiah Kale, the Philadelphia brick maker, seemed to dominate the business. In 1799, when he and his partner, Carter, advertised for forty to fifty hands to make bricks, they didn't specifically solicit Negroes or slaves, which was probably a way to invite free blacks and whites to apply. They also announced that they needed the bricks for the boardinghouses that Daniel Carroll of Duddington wanted to build on Capitol Hill to house congressmen. There is no better symbol of how the rural ideal of families making bricks was ended by the enormous demand for bricks. So it is doubtful that slave families, women and girls too, made bricks in the city.

True, we aren't sure who made the bricks for the mansion Carroll built for himself that was finished in 1797. The supply of bricks Carroll had amassed was depleted in 1794 when he sold many to Greenleaf. But it is unlikely that

Carroll forced his and his relatives' slaves to make bricks for his house, at least on his own property. As building progressed in the city, he developed an aversion to clay pits. After Mitchell's brick-making crews were thwarted by fevers, the commissioners ordered pits for clay dug higher up on Capitol Hill for reasons of health. Carroll objected that they made the area near his house unsightly. To supply Carroll with bricks in 1799, Carter and Kale dug clay and burned bricks on Pennsylvania Avenue, which earned them a warning to desist from the commissioners.

That we can't be sure who made all the bricks used in the public and private buildings makes sense in one respect. Those who made bricks tended to all become the color of the clay they worked.

As the career of William Hill suggests, African Americans were also good bricklayers. But while we don't have the payrolls of the contractors who made bricks, there are payrolls for bricklayers in the commissioners' records. They suggest that almost all the bricklaying was done by white workers. "Negro William" was listed on the May 1796 payroll for bricklaying work at the White House along with free workers named Brown, Maitland and Tweedy. They made eleven shillings a day, and William made ten for his master. William isn't on any other payrolls.

However, much of the bricklaying was done by a contractor named Allen Wyley who negotiated a piecework contract with the commissioners. There are no payrolls associated with the work his crew did, so that leaves open the possibility that Wyley hired slaves or used his own slaves to do the bricklaying. However, Wyley was not a merchant like Mitchell and Deakins. He is on a March 1797 payroll with nine other men working under Patrick Farrell, who was also a bricklayer. All appeared to be free workers earning the same wage per day. All southern merchants were in a network that alerted them to the availability of slaves for hire or purchase. A full-time free bricklayer had a network of other free bricklayers he could tap.

As the wage William made suggests, slave masters who owned skilled slaves were not hiring them out at laborers' wages. Wyley would have only slightly lowered his labor costs by hiring slaves, whom he would have had to feed, too. Of course, he could have hired free black bricklayers. We can wish he had, but we can't prove it.

The commissioners did provide laborers to tend the bricklayers. They cautioned Wyley not to hire more than twenty hands because they feared they would not have enough laborers to spare. As with the masons, the laborers would manage the scaffolding, which they would put up inside the buildings, and deliver the bricks to Wyley's men.

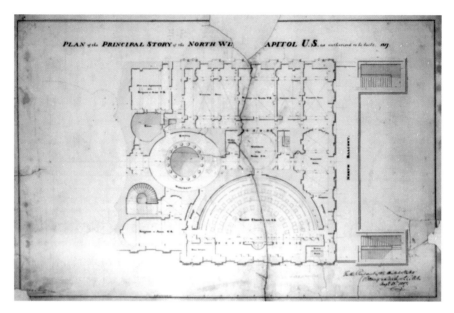

The only drawing of the floor plan of the North Wing of the Capitol showing that interior work was as challenging as raising the stone walls. *From the Library of Congress.*

The use of bricks to back the stone walls strikes us as relatively easy, pro forma work, but the brick work to make the interior walls was another matter. Oval and elliptical rooms were in fashion in the 1790s, and the large elliptically shaped Senate Chamber would soon become the focus of national attention.

Perhaps there was little attention on the race of the men doing the work because the work became so challenging. So there was no reason to take notice if Negro William was on Wyley's crew, unless you were his master.

We have an idea who that master was. In April 1797, Clotworthy Stephenson placed an ad cautioning people against employing Negro Will, a bricklayer and plasterer, without permission. The ad suggested he was lurking in or about Georgetown. Stephenson was a skilled joiner and carpenter and Hoban's right-hand man, and Hoban superintended construction at the White House. So "Negro William" who worked as a bricklayer in 1796 likely belonged to Stephenson, which explains why he could find work at the White House in a crew of just four men.

The ad also suggests the frustration of slaves who could not market their own skills. Stephenson was not a man to cross. He lived near Hoban on the President's Square and, like Hoban, was one of the leaders of the city's

Masonic lodge. The slave hire system would mature so that slaves could market their skills, but ads like Stephenson's suggest that was not the case in the 1790s.

Another ad for another runaway that Stephenson placed doesn't quite give another example of the frustrations of skilled slaves. But it reminds us that slavery was not an educational system that provided on-the-job training to empower African Americans. The 1799 ad sought the return of an eleven- or twelve-year-old slave boy named Scarlett who had been learning the "bricklaying and plastering trade" and was instead allegedly "skulking either in town or in vicinity as he has sold most of the clothes & I expect he is almost naked."

Runaway ads are the stanzas in the satanic verses written by the master class. In them we find the only vital statistics we have about slaves, but in the case of Scarlett, we have only his age, eleven or twelve. The name suggests what portion of Irish blood might have run in his veins. Slaves who ran away from masters in cities were usually associated with a trade, as if to justify the continuation of a slave system premised on the insistence that only people of African descent could work fields given the climate of the South. What city couldn't use more bricklayers and plasterers, so hats off to Clotworthy Stephenson for training one. The runaway ad allowed the master to put a value on his efforts to train the slave. In this case, it was fifty cents. When such a low value is placed on a slave's return, the master usually adds something derogatory about the slave to absolve the master. In this case, the ad concludes with a brief word reminding readers of that pervasive flaw in slaves, their irresponsible nature.

Of course, Scarlett was a child. Growing up on President's Square, there is no telling how much he contributed to building the White House. Or perhaps he had a childhood, and as he gamboled near the hired slaves who came from St. Mary's, Charles and Prince George's Counties, he made their day somewhat easier. He at least made clear to them how their situation had changed.

They were all men taken from the women, children and elders they knew and forced to work and live on sea rations while surrounded by fields of corn, wheat and oats.

In the last chapter, we'll examine more work that the slaves did, including plastering, even as the commissioners dismantled their slave hire system. In the next chapter, let's examine the strange lives they were forced to live.

Living Conditions

A bell rang out to start the workday. One weighing 220 pounds was shipped down from Baltimore. At first, one of Hoban's indentured servants rang it. Then, after the commissioners objected to Hoban hiring his own slaves and servants, they paid a white laborer one dollar a month extra to ring the bell. Almost all the workers lived near the work sites. The skilled masons and carpenters came out of temporary wooden and brick houses and some with bricknogged walls—that is, walls made with crisscrossed wood that were filled with common bricks.

The hired laborers came out of their log camps. Since their overseers slept near them and we know that one slept near the White House while the other slept near the Capitol, it's likely that the laborers were divided into two camps. Free and slave laborers probably mustered together. The defining feature of the laborers was not their race but that they were single men who did hard, menial jobs. Some of the skilled workers were married. Even when they sent out calls to Europe for laborers, the commissioners always solicited single men.

All of the laborers and many of the single skilled workers got rations supplied by the commissioners. No one ever described their breakfast except to suggest that there was no chocolate butter. The commissioners hired one cook who worked at the Capitol Square. The Polish tourist Niemcewicz observed the masons eating breakfast at eight o'clock in the morning, roughly two hours after sunrise when work began. Everyone else likely ate at the same time.

The commissioners bought shoes for several slaves and deducted the cost from what they paid masters. *Photo by Bob Arnebeck, from the Collection of the Mercer Museum of the Bucks County Historical Society.*

An overseer at the White House described his job as "nothing else but attend[ing] laborers and issue[ing] their provisions." Evidently, a wagon took the food to the overseers at the work sites, and they handed it out. When the numbers of laborers swelled, there were two or three overseers at each site. Food for the speculators' workers was prepared at a camboose, a large portable stove; perhaps the commissioners' cook had the same convenience.

The rations issued to the workers were salt meat, bread or cornmeal. In the eighteenth century, it was common to have meat at breakfast. One gets the sinking feeling that the workers got the same meal three times a day. The overseers got the same rations. After eating them for a year, Samuel Smallwood finally complained to the commissioners about his "Diet which are nothing more than Salt meat for Breakfast Dinner and Supper which is neither palitabel nor Constitutional." To supplement that fare with "tea Sugar and other Vegitables" would "reduce" his fifteen-dollars-a-month wage "to a mear nothing." But he didn't want another job. The commissioners gave Smallwood a raise to twenty dollars but still no vegetables.

The hired slaves had no money to buy anything to supplement their diet. Undoubtedly, back on the plantation, they had access to gardens, but there is no evidence that they had that luxury in the city of Washington despite being surrounded by fields of wheat, oats and corn. They were single men, far from home, doing hard physical labor from dawn to dusk six days a week.

There seemed to be two seasonal variations in their diet. In the spring, they got salted herring caught in the nearby Potomac. The commissioners made a point of ordering that the barrels of the "best herring" go to the laborers and that they only get pork four days a week as long as the herring held out. The commissioners preferred buying cheaper Indian meal, or cornmeal, rather than flour, but often in the late winter, Indian meal could not be bought, and they had to buy bread from Georgetown bakers. One February, they bought 66 loaves for workers at the White House for three days. One March, they bought 203 loaves of bread at six cents apiece.

The commissioners felt compelled to make up for such extravagance by finding the cheapest source of salt pork. They discovered that northern pork was cheaper than southern pork. Then they discovered that the northern pork that they bought in Baltimore came from farther north, and they asked Deakins to track down a supply from Boston, New York or Philadelphia because the price must be cheaper at the source.

What the cooks, first Thomas Smith and then Jane Short, did with the positively cheapest salt pork in America is not known, but the hired slaves got it three times a day when the shad weren't running. On paper, salt beef

Almost all the food served three times a day to the slaves was salt meat or Indian meal. The commissioners sought barrels of cheap salt pork from as far away as Boston. *Photo by Bob Arnebeck, from the Collection of the Mercer Museum of the Bucks County Historical Society.*

made up another part of the rations, but despite Samuel Davidson letting forty-six head of cattle pasture near the President's Square, the price of beef was usually too high.

In 1798, as workers strained to finish the walls of the Capitol, the commissioners contracted with Middleton Belt for the delivery of enough beef, "an equal number of fore and hind quarters, the beef to be well butchered," to supply 1¼ pounds daily to each of the 180 workers then getting rations. This may have been fresh meat. The cook Jane Short made as much as the laborers, sixty dollars a year, which doesn't necessarily mean she didn't put her heart into her cooking.

According to Niemcewicz, the workers were summoned by the bell to eat their dinner at one o'clock. Masons stopped work at six o'clock. Perhaps then the hired laborers had a light supper before they were compelled to continue working until dusk. Also according to Niemcewicz, the skilled workers frequently visited grogshops that ringed both the President's and Capitol Squares.

During the hot months or when working out in the cold, the hired slaves also got a ration of whiskey or rum. In that day, liquor was deemed a stimulant conducive to hard work. But it meant more than that to the single men, white and black, who were stuck in a city with virtually no houses save the crowded, poorly built structures they had to live in. A joke made during a rather serious occasion made the point.

After the commissioners fired their head carpenter, he demanded and received a hearing. One of the commissioners' charges against Peirce Purcell was that he had set a bad example three years earlier by chartering a sloop from Charleston, South Carolina, freighted with liquor. Purcell admitted, "It is well known to many in this city that I chartered a sloop from Charleston. And brought here Porter, Brandy, Gin & C to the amount of 400 Pounds Sterling and barrels of nails." That's about $1,600 worth of liquor. Then the devil in Purcell had to make the point that the liquor was all gone. He added apropos the barrels of nails that he was "using one yet."

The commissioners licensed establishments to sell liquor and periodically had establishments without a license torn down. As has often been told, in 1795, they had a "disorderly house" on the President's Square torn down. It's rarely pointed out that James Hoban rented the house to Betsy Donako and her lovely ladies. Especially in the mid-1790s before ladies moved to the city, society was organized for the pleasure of single workingmen.

Of course, those entertainments were designed to entice white workers. That the hired slaves could ever afford a stiff drink is unlikely, which didn't prevent the powers-that-be from worrying about it. On August 4, 1795, Georgetown banned the sale of liquor to slaves along with having any other dealings with a slave without permission of the slave's master. In the city of Washington, the commissioners made the rules and evidently tolerated the single workers' way of life, which could be demoralizing for those not living it.

Given the summer heats and prevalence of the "fever and ague," William Cranch, who was fresh from Massachusetts, thought it remarkable that few had died "considering the number of workmen here and considering their mode of life, their imprudences, and their bad provisions."

Cranch did not describe how the hired slaves fared in this singles' scene without women. It is tempting to suggest that as more white workers came to the city, slaves were crowded out, but as those white workers earned money, some bought slaves. Recall all the inconveniences of the city, including the distances from shops to the work sites where workers lived. Slave servants walked the extra miles for their masters, as well as kept house.

Thomas Middleton, an English cabinetmaker living on the President's Square, had both a little "yellow girl" and "Negro Jack" to make his life easier. The blacksmith Gridley also bought a slave girl to keep his house. Of course, Scarlett lived on the President's Square and perhaps his mother too, as well as slave women who cared for Hoban and Peirce Purcell and their slaves.

Gridley was from New England. There was no abolition sentiment in the Yankees who came to work in the city. The Underground Railroad had not been established, and neither had the railroad. William Cranch avoided buying a slave himself, but his brother-in-law James Greenleaf gave one to his sister to help Cranch's growing family. Greenleaf gave her Solomon on condition that he be freed in five years if he was good, eight years if he was bad.

But although they lived closer to them, it was probably not among the newly hired servants of the white workers living near the work sites that the commissioners' hired slaves found congenial society. The gentle hill southeast of the Capitol had a population of slaves who had been settled there for years. They were the consternation of speculators and entrepreneurs like James Barry who wanted to ship goods to India. He complained about "old brick sheds" inhabited by "shades of all colors." How, he asked, was he "to break ground by placing a building or improvements within 30 or 40 feet of the hovels & purloins [*sic*] of this class?"

Unfortunately, no one sympathetic to African Americans wrote about how they lived in the city. So the only hint of relationships between the hired slaves and those who lived there all their lives is from what today we call crime reports.

Daniel Carroll of Duddington, the self-appointed citizens' watch of Capitol Hill, accused some of the commissioners' hired slaves of receiving stolen goods. The commissioners tried their best to ignore it. Carroll kept pressing them, and there was a court hearing, the result of which is unknown. In December 1797, the watchful David Burnes on the other side of town published the names of four slaves, Peter, Jonah, Moses and Ester, accused of theft and receiving stolen goods but did not mention their masters. What was stolen was not mentioned either, but it might very well have been the fruits and vegetables lacking in the hired slaves' diet. A landowner along the

Anacostia River publicly warned "blacks and whites" to stay away from his apple orchards.

There was no police force in the city. The commissioners complained to the "constable" that he was neglecting his duty in "execution of criminal process against those persons who commit depredations on the Public Property in city" but not to police their hired slaves. After there was a theft of building materials on the President's Square, the commissioners placed a night guard made up of white laborers. A criminal was caught and jailed on President's Square. There is no record of the upshot of the arrest.

It is unlikely the man they caught was a hired slave. No guard was ever placed around the laborers' camps. The commissioners did not hire tough guys for their overseers. They preferred good handwriting and a head for figures. Isaac Naismith had just completed a "liberal education" and had been referred to the commissioners by a prominent Maryland official. Naismith had no idea why, given that background, he had been made an overseer. Judging from a letter Samuel Smallwood wrote to the commissioners, he envied the slaves. He was vexed that he had to sweat over attendance sheets and payrolls after the bell rang marking the end of the workday.

However, one night in the summer of 1798 when the number of hired slaves camped on Capitol Hill peaked, Smallwood wrote to the commissioners worrying that the slaves might attack him, but not because of the anger of the slaves. That summer, a feud between Irish carpenters and English and American workers reached a boiling point. After he reported that he was assaulted by an Irish carpenter, Smallwood worried, "I am not safe in my situation for how do I know but a certain class of peopel may entice even the blackis to commit depredations on me." The commissioners did not offer protection, and the situation blew over.

There is no doubt that slaves were whipped in the city, but more likely this was done by masters of the upper class. Samuel Davidson, who sold a slave to Commissioner Scott, gave this advice to a Baltimore merchant to whom he sold a slave named John: "A little hickory oil, early and judiciously applied to him will…render him a very valuable slave."

Hired slaves were someone else's property. If one was absent, the commissioners simply paid his master less and left it to the master to discipline him. Tempers did flare in the city, but the only recorded instance of a whipping was when a British land speculator horsewhipped William Cranch, who was then Greenleaf's lawyer.

Not for nothing did the commissioners allow a young preacher to give Sunday services at one of the Capitol Square work sheds. He was rather

popular. One rich Georgetown merchant ordered a "jaunting car" from Scotland so his wife could use it to get to the Capitol on Sunday. The Polish tourist Niemcewicz went there for one service, and that was our best chance to find out what the hired slaves did on Sunday. He described the congregation of about two hundred as mostly workers and others living in the vicinity along with their wives. He didn't take notice of any slaves. Only among the women did he notice skin color: "The women, mostly farmer's wives or wives of the inhabitants and officers of the town, were very healthy, very white skinned, very pretty."

We can only speculate how the hired slaves spent their Sunday. There were laws in Georgetown discouraging slaves gathering, but there were also churches. We know that the Catholic church there had African Americans in its congregation. One hired slave whose subsequent life we now know about, Ignatius Beck, became a member of the African Methodist Episcopal church in Philadelphia, so he might have been attracted to a church or organized a prayer service on Sunday.

From a runaway ad, we know that Fidelio had "his fiddle with him on which he is fond of scratching in negro assemblies." Slaves could enjoy themselves, perhaps even by trying to supplement their diet. Andrew Ellicott and his assistant surveyors used to search the woods for something to eat and once found huckleberries. A young woman who arrived in the city in 1800 was overwhelmed by the neglected streets and squares overgrown by blueberry bushes. Or the hired slaves could have done what the commissioners warned overseers not to allow them to do from dawn to dusk on any other day. They could have sat down and had a long rest.

That hired slaves might have gone to church in Georgetown or at the Capitol joining white people may have been unlikely because the hired slaves did not have respectable clothes, perhaps not even a change of clothes. It was their master's responsibility to clothe them, and rough cotton three-quarter cut pants and a loose smock that were the working slave's typical clothing was probably all their masters gave them. Judging from runaway ads, better clothing prompted not a few slaves to run away.

There are receipts in the commissioners' records showing that they bought shoes for the hired slaves. Those records are spare in their description of what the cobbler did, for example: "1 pare shoes for Jery, property of Susah Mills 0 12 6." That's about a week's wages deducted from payments sent to Mills.

There is one interesting similarity among the record of payments to cobblers. All the hired slaves who got new shoes were owned by women. A July 7, 1796 receipt from a man named Delphey lists shoes made for six slaves

In this receipt for new shoes for slaves, all the slave masters were women. *From the National Archives.*

who belonged to the Brent sisters; for Fielder and William, who were owned by Elizabeth Thomas; and Jery and Clinton, who belonged to Susannah Mills. Perhaps female slave owners were more solicitous for their slaves' welfare or appearance and encouraged the commissioners to buy them new shoes.

The obligations of the commissioners and masters arising from the slave hire contract gave the slaves some leverage to ensure their own welfare. The contract required the master to give them a blanket and the commissioners to give them a place to sleep. In November 1797, the commissioners ordered "carpenters' chips" be given to "public laborers" for firewood once a week. There is no evidence that any slaves argued that the contract implied they would get a place to sleep that was reasonably warm. But they did get the chips.

When the brick-making contractor John Mitchell heard that Bennett Fenwick, whose slaves dug clay, was planning to "bring smallpox to the city" and inoculate members of his family, the commissioners' hired slaves soon knew about it. A group of them approached the commissioners and asked to be inoculated against smallpox. The commissioners sent ten of them to the hospital and deducted the doctor's fee for those inoculations from the wages sent to the slaves' masters. We know the inoculation of "Negro Emmanuel" who worked at the Capitol cost his master Alexander Scott seventeen shillings and six pence. But the commissioners did suffer a loss. It took a patient several days to recover from the hopefully mild case of smallpox caused by inoculation, and that year, the commissioners had promised masters not to deduct wages for time not on the job if their slave was sick.

The slaves knew how, or were advised how, to protect themselves from a deadly scourge. It helped that there was a system in place they could use. By tradition, masters were obliged to give medical care to their slaves. When slaves were hired out to do potentially dangerous work, masters expected an explicit guarantee of medical care. Of course, provision was often made for medical care for anybody working in a remote area. A 1786 payroll listing the white indentured servants working for the Potomac Company also listed a nurse, Margrett Cosgrove.

In 1791, before they hired slaves, the commissioners paid Dr. Worthington of Georgetown for "physick for workmen." In their ad for slave laborers in April 1792, they didn't promise medical care, but they did provide it, and every subsequent ad made that promise.

During the congressional debate over where to put the national capital, northerners warned that a capital along the Potomac would be "sickly," which is to say that there would be endemic fevers. Thus all interested in the success of the city of Washington united in minimizing any reports of sickness in the area. The summer of 1792 was especially sickly, but it escaped national notice. In the summer of 1793, Philadelphia newspapers carried a report that the "flux" or dysentery was widespread and deadly around Georgetown.

To counter that, Hoban, Williamson and Williams sent the results of a census to newspapers around the country. There were 820 people in the city, and not one had died in the last six months. They added, "It is to be observed, that of the above number a great proportion are artists in the different branches of building, and from the different parts of America & Europe, the climate agrees with their constitutions, and they enjoy in this city equal if not superior health to what they have experienced in any part of the continent." There was no mention if slaves were counted.

Then that fall, a deadly yellow fever epidemic struck Philadelphia and killed upward of five thousand people by the time it ended in November. Much credit was given to a temporary hospital for treating victims. In December 1793, the commissioners ordered Hoban to build a "house suitable for a temporary hospital on some public ground convenient to a spring."

The temporary hospital was not for everyone, only the hired laborers. The Philadelphia epidemic set off a national debate about the epidemic's causes and possible preventatives. That the poor who could not get medical care helped spread disease was brought home to the commissioners. Plus, after two years of hiring around forty yearly hands, they wanted to almost double that. Isolating and treating workers who got fevers might keep the

These lancets used for bleeding patients were familiar to slaves sent to the hospital. But there was also tea, sugar and molasses, which was never part of their daily rations. *From the United States Navy.*

whole workforce from getting sick. That the commissioners built a hospital suggests how cramped the laborers' camps might have been.

Of course, today we think all the medicines and treatments given in eighteenth-century hospitals should be avoided. The typical diseases were malaria and dysentery. Treatments included bitter-tasting Peruvian bark that later was learned to contain quinine and an inorganic mercury compound called calomel that was sweet tasting but harsh on the gums and stomach. In the last two months of 1798, Dr. Frederick May saw patients in the hospital fifty times. He bled six times and gave twenty-four doses of cathartic, probably calomel.

But in the context of the times, it's probably not a place we would have avoided. It is where Samuel Smallwood would have found the tea and sugar he craved. A receipt for hospital supplies shows frequent deliveries of brown

141

sugar and Bohea tea by the pound, as well as gallons of molasses and at least one bottle of port wine. All that helped the medicine get down.

Hoban built the hospital on what was designated as Judiciary Square a few blocks north of Pennsylvania Avenue, closer to the Capitol than to the White House. It was inspected by a doctor before winter and found "not sufficient for the sick, there is no upper floor, neither is there any more than the weather boarding on the side."

But the hired slaves did not shy from the hospital. Patients were nursed by Mrs. Chloe Leclair. Some historians wonder if she might have been a woman of color, perhaps a recent refugee from Haiti, where slaves had rebelled, causing the French and their servants to flee. Perhaps, but by November 1795, she was replaced by Mrs. McMahon, who kept the job until 1799. Both nurses earned ten dollars a month.

Hiring a doctor was more difficult. The commissioners offered Dr. Worthington the job of caring for sick laborers for a fee of twenty Guineas (about $100) a year, and they would call him the "city physician." This suggests the commissioners had an eye to protecting the city's reputation by assuring medical care for all its citizens. Worthington declined the offer.

They contracted with Dr. John Crocker to attend "the Negroes and such of the white men as we have generally paid the Doctor for attending." From May 1, 1794, to May 1, 1795, that amounted to seventy-two slaves and forty-three white laborers. His total bill came to $166. A few years later, the commissioners had Captain Williams check on the number of sick laborers at the hospital, and he reported that on average there were five or six there each day.

The laborers were probably taken to the hospital to see the doctor rather than sent by the doctor to the hospital. There is receipt in the records of a carter hauling two sick Negroes to the hospital.

As far as the records of the commissioners go, that was the extent of services, lodging, clothing, meals and medical care provided to the hired slaves. The commissioners rued the expense. In 1795, the hospital cost them $1,196. In 1798, Dr. May billed them for $325.60 for just two months of treatments. He treated one patient with venereal disease, which cost $7.50. Add to that the money spent feeding the slaves, which was compounded when contractors who received advances for procuring pork and Indian meal never delivered. Richard Forrest, a bankrupt Georgetown merchant, owed them $814 advanced for Indian meal.

The expense of supporting their hired-slave lifestyle, meager though it may seem to us, became a reason for the commissioners to drastically cut

back on the number of slaves they hired. Their doing that seems strange. Many doubted that the White House would be ready in time, and there was jockeying to rent a house to the president and his family.

So that memorable year in the city's history was one that most of the hired slaves who helped make it possible missed. White people never really considered slaves a part of the city's history, especially those hired from faraway plantations. Of course, in 1800, there were more slaves in the city then ever before doing the dirty work as usual along with the Irish.

1800

The commissioners dismantled their slave hire system a year before the White House and Capitol were open for business. That the laborers' camps and hospital were gone was not noticed in letters or newspaper reports. Of course, there was no notice of them when they were there. There is nothing in the records, letters or newspapers suggesting that anyone gave a thought as to what happened to the 120 yearly hires, 90 of them slaves, who were gone. Of course, at the same time, the commissioners fired most of their stonecutters and masons. No one seemed to notice that either.

With the masons gone, obviously the hired laborers no longer had to attend them. But to finish the interior of both buildings, the commissioners had to hire many more carpenters. They moved into the temporary buildings on and around President's Square that the masons vacated. The commissioners justified not having laborers to attend the carpenters because in 1799, there were no more timbers to position, no more rafters and planks to move. The heavy lifting was over. The interior work required small boards and finer work. As already mentioned, the commissioners hired out their sawyers to contractors at $16 a month, but in 1799, probably only around ten sawyers were involved rather than the crew of twenty-five the commissioners had in 1798. In 1800, they hired fewer. The last receipt for payment to a master who hired out slaves that the commissioners used as sawyers was $19.74 to Joseph Queen on June 7, 1800.

What the commissioners did seems logical and saved money, but there remained so much more work to do. Other than finishing the interiors of

the buildings, the work left to be done included construction of buildings for the executive offices, leveling and paving avenues and streets, making sidewalks or footpaths as they called them and then landscaping the Capitol and President's Squares, especially the latter, not to mention building the South Wing and Rotunda of the Capitol. Finally, some landowners wanted a canal through the city as outlined in L'Enfant's plan. In his work plan, L'Enfant had called for 870 laborers to do all that. They were the first hired and, if he had remained in charge, would have been the last fired.

From 1792 through 1798, the commissioners had delighted in using the hired slaves to ensure that masons had no excuse for not doing their work in a timely manner. In 1799 and 1800, it seems that the commissioners didn't want one hundred slaves around, thus giving themselves no excuse for not doing the 101 things left undone.

Of course, the commissioners had a money problem. Their contract with Greenleaf, Morris and Nicholson guaranteed at least $68,000 a year through 1800, but thanks to the speculators' bankruptcies, no money came from them. Beginning in 1795, the commissioners had difficulty paying their bills. By not hiring slaves, they realized other savings. In 1799, when there were only "12 to 14 laborers" at the Capitol, they gave Jane Short the cook notice, as well as Nurse McMahon. The dismissal of women who had worked for the commissioners for several years was made without ceremony or thanks. Dr. May asked the commissioners to at least give Mrs. McMahon a letter commending her for her work at the hospital. The commissioners put the hospital up for rent or sale. James Dermott offered to haul it off Judiciary Square so it no longer had to be called a temporary building. The commissioners also gave notice to Elisha Williams, who had hired the slaves for them since 1792, but not before he sold all the "drays, carts, barrows and tools & c," the slaves had used.

However, the money saved by not hiring slaves did not amount to much. In 1798, the commissioners began paying $70 for yearly slave hire and $60 for slaves hired from April through December. The three commissioners were each paid $1,600 a year. That's $4,800 or what it would cost to hire eighty slaves.

During hard times, every savings helps, but the federal government for whom the commissioners toiled was not going through hard times. There was no overarching fiscal necessity for the commissioners to cut back. The federal government had raised taxes, even taxing property owners based on the number of windows on their house, in order to build a navy and raise an army. The navy fought what is known as the Quasi-War with France.

The army prepared to ward off a French invasion but fired not a shot in anger. A new army regiment was stationed in Shepherdstown, seventy-five miles upriver from the city.

Guided by its secretary, Benjamin Stoddert, the navy department was building the largest of its six navy yards on the Anacostia River just below the Capitol. The only help the commissioners asked from the revitalized military were some marines to replace the night guards at the White House, which would save thirty dollars a month.

Congress trusted U.S. Navy secretary Benjamin Stoddert to get the city ready for the arrival of the government in 1800. *From the United States Navy.*

The trouble was not lack of money but lack of confidence in the commissioners. Their reputation was never very high, but in 1800, it couldn't get much lower. Every December, beginning in 1795, Commissioner White spent as long as half a year in Philadelphia begging Congress for money to carry on the work. Congress did just enough so the work could continue. In 1800, knowing that 32 senators and 106 congressmen would have to live in the city while Congress was in session, and around 100 bureaucrats and the president would soon move to the city permanently, Congress was careful not to give the money to get the city ready to the commissioners. The appropriation went to the four cabinet secretaries, which in effect put Stoddert, a Georgetown merchant and major land speculator in the city, in charge of spending it. Of the four cabinet secretaries, only he had been to the city. Indeed, he had been instrumental in its founding.

There is no evidence that using hired slaves even entered Stoddert's mind, even though he owned thirteen in 1790. Stoddert, who was fifty-six years old in 1800, had been a merchant who made it rich by speculating on the federal government's assumption of the states' Revolutionary War debts. Once rich, Stoddert did not buy a plantation. Instead, he bought Washington lots and

aimed to build the largest house in Georgetown, which he called Halcyon. When faced with a problem, his first instinct was to hire a Baltimore contractor, not slaves.

Of course, we have to be careful not to assume that private contractors from Baltimore or elsewhere didn't use slaves, but it seems the men who had profited off slave hire became more interested in selling slaves. Robert Sutton, who had taken a crew of slaves downriver to get Light-Horse Harry's timber, began selling slaves. Of course, those sold were not necessarily able-bodied men. Sutton advertised the sale of slaves "large and small." Meanwhile, Sutton got a job as a carpenter at the White House. In the spring of 1799, James Blake, who had hired out his own and his clients' slaves to the commissioners, began selling slaves.

Some contractors did use the commissioners' hired slaves. Plastering began at the Capitol in the fall of 1798 as soon as the interior rooms were bricked and lathed. Work continued through the fall of 1800. The contractor, John Kearney, started with ten workers. The commissioners ordered him to hire more and gave him three more hired slaves to help. On average, four or five of them worked with the plasterers, amounting to sixty-five and a half months of work. Here, too, the commissioners charged the contractor sixteen dollars a month for the hands. We don't know exactly what the hired slaves did, save that in June 1799, the commissioners ordered a half pint of whiskey a day for the slaves boiling plaster of Paris.

Only if one assumes that only slave masters answered the help-wanted ads in the newspapers can one suggest that contractors hired all those slaves once hired by the commissioners. On February 18, 1800, the contractor Hugh Dinsley advertised for "20 good hands for plastering the President's House" starting March 1. Slaves often did plastering, but Dinsley's expectation that he could get the hands within two weeks suggests he was after free, not slave, labor.

Thanks to a diary kept by Mrs. Thornton, we get a glimpse of Dinsley's men in action. Two came to whitewash the interior walls of the Thorntons' house and did such a bad job that the Thorntons insisted that Dinsley come and rectify the mess. No mention was made of the race of the workers in her diary, which suggests they were poorly trained free workers rather than hired slaves who probably wouldn't have been hired without the slaves giving evidence of having some skill.

Judging from Mrs. Thornton's diary, there was no lack of slaves who wanted to be hired, though many of them were women looking for domestic work and boys. Three "young negro women" came all the way from Upper Marlboro, Maryland, fifteen miles away, and she hired one to come back at

This photo taken by Abbie Rowe during the 1949 renovation of the White House shows the challenging interior work done by carpenters, bricklayers, plasterers and the slave laborers who tended them. *From the National Archives Truman Library.*

the beginning of the week. Commissioner Thornton hired "a Negro Lad" for under fifty dollars a year. He found it more difficult to get good able-bodied male slaves. In the summer, he hired slaves by the month to work on his horse farm northwest of the city. That didn't work out well. On August 30, Mrs. Thornton wrote, "Dr. T found that it was the hired Negroes that stole the cabbage—they both went off."

Since most of the commissioners' hired slaves had been helping masons and carpenters, it might have made sense for private builders to use them. The commissioners awarded contracts to the lowest bidder, and since 1792, the commissioners had led the way in using slaves to try to suppress wages. Leonard Harbaugh, who had made contracts with the commissioners since 1792, won the bid to build the treasury department, a two-story brick building just east of the White House. Some of Harbaugh's payrolls wound up in the commissioners' records. They show nine free carpenters working with the help of three laborers including "Negro Frank" and "Negro Lin." Nine masons worked on the brick building attended by eight laborers, all free.

In 1800, the navy department rivaled the commissioners as the largest employer in the city. Around one hundred men were hired to build wharves and to fill thirty to forty wheelbarrows with dirt to dump along the shores of the Anacostia River. Evidently not many of those men were slaves.

There was a dispute aired in the newspaper about whether the contractor in charge was pocketing money the navy department had budgeted for the laborers doing the work. He was accused of paying them seventy-five cents a day instead of one dollar. In his defense, the contractor claimed that he made up the one dollar a day for laborers in the liberality of his provisions, which included "roast beef, boiled beef, light bread, jonny cake, whiskey two or three times a day."

The commissioners' hired slaves were never paid or fed like that. Their masters rarely got more than $6.66 a month, not $4.50 a week.

So the commissioners' slave hire system ended, and probably most of the slaves involved in it were back working on plantations. There was no storybook ending to their years of sacrifice. There would be no moment when they could walk through the completed Capitol and perhaps feel, if not sit in, the Moroccan leather seats in the Senate Chamber. There was no moment of realization that the White House really would soon be the home for the president.

It's difficult to answer the question of why the hired slaves continued to work even though their masters got the money they earned. While there is no evidence that they were whipped, there is also no evidence that they were

exhorted to work harder so the buildings would be ready for the government by the 1800 deadline. The slave system gave them no way out of their predicament, but being human, the slaves may have felt some pride and excitement in the grandeur they were building.

None of the free workers had a storybook ending either. The commissioners tried to fire Hoban before the White House was fairly done. The custom at the completion of a building was to have a dinner in celebration for all the men who helped build it. The commissioners bucked that tradition. Even the bankrupt speculators Morris and Nicholson had an ox roast when they half finished twenty small brick buildings.

So in evaluating the commissioners' slave hire system, we cannot present the successful completion of the White House and Capitol as evidence of its success. The slaves weren't there for that. We could say the slave hire system answered the needs of a city in the making but not the needs of a city getting ready for the show, for the arrival of Congress and the president. However, that gives the commissioners more credit for being astute managers than any contemporary accorded them and unjustly demeans the slaves. As this book tries to show, the slaves creditably did what they were told to do, and there's no reason to think that they could not have continued to make a contribution if managed more wisely.

The commissioners never gave a thought to managing slaves beyond making sure they worked from dawn to dusk and got building materials to free workers so those free workers would have no excuse for being idle either. Recall that in 1793, the commissioners lauded their slave hire system for checking the demands of free workers. Although a more technical analysis of the work and pay structure needs to be done, there is no evidence that hiring slaves kept the wages of skilled workers lower.

When they stopped hiring slaves, the commissioners stopped hiring free laborers, too. So they evidently no longer thought yearly labor hire had any bearing on wages. Instead, they kept a close eye on wage rates in other cities. In 1800, they tried to fire carpenters who would not work for Philadelphia wages that meant a 10 percent cut in their current wage. The commissioners backed off when someone explained that Philadelphia carpenters would not rush to the city to work for the same wage they were already getting.

From 1792 to 1798, the commissioners did trap free laborers into accepting the same pay slave masters got for hiring out their slaves as laborers. That impressed Thomas Jefferson. While secretary of state, he never commented on the commissioners' policy to hire laborers by the year. But when he became president, the commissioners' hiring slaves to beggar

free laborers looked attractive to him. In 1802, he wanted to build a dry dock so all the large warships of the navy could be stored where both the president and Congress could keep them under close inspection. At the same time, Jefferson was trying to cut taxes and government expenditures. Dry-docking the navy would cut expenses, and he wanted to build the dry docks as cheaply as possible.

He asked Benjamin Latrobe to design a huge dry dock along the Anacostia River, and at the same time he explained the advantages of the slave hire system. At the first of the year, "any number of laborers can be hired here." If that deadline was not met, "the work must lie over for a year, or be executed by day laborers at double expence." Of course, "any number of laborers" could be had at the first of the year because that's when masters hired out their slaves. Congress rejected the dry dock. Jefferson's impression that slave hire could cut labor costs in half was naïve. No public works project was ever postponed a year just so slaves could be hired cheaply, although when he summoned Latrobe to Washington to build the South Wing of the Capitol, Jefferson again urged haste so that "laborers" could be hired to work at the Aquia quarries. (Jefferson had rarely been in the city in the 1790s, and his sources of information about how hired slaves had been used on the public works were probably Robert Brent, whom he appointed mayor of Washington, and Thornton, whom he appointed to head the patent office. The reputations of both men were heavily invested in the slave hire system.)

Slave laborers continued to be hired for future public and private work in the city, but the commissioners' slave hire system that put laborers in camps and provided meals and a hospital was never replicated. Only the commissioners' passion for keeping wages low endured in the employment policies of the government. In the 1820s, someone finally objected.

John Sessford provided annual updates of building activity in the city to the *National Intelligencer* newspaper. In 1826, when the Capitol as conceived by George Washington was almost completed, he opined, "It is much to be regretted that there is such a general disposition shown to reduce the pay of the laborers to so small a pittance, and to the introduction and employment of non-resident slaves; a policy which is injurious to the city." There is no better indictment of the commissioners' policy toward laborers.

Like so many members of the upper class in the late eighteenth century, the commissioners fancied themselves experts on how to manage a system of checks and balances that would run on its own accord. Although their workforce never totaled more than two hundred men including slaves, the commissioners never took a personal interest in any of them, slave or free.

To use a cliché, the workers were cogs in a machine, not people. Save for the thirteen cents a day slave sawyers got in extra wages, those cogs who were slaves were never even greased.

Fortunately, the system that the commissioners put in place did not approach the demeaning dimensions described by W.E.B. Du Bois in his history of Reconstruction in the South after the Civil War. Then, white and black workers were separated by walls of white racism and fear fostered by an upper class knowing that any unity among workers could only diminish its power to keep wages low for all workers.

So the commissioners deserve some understanding, maybe credit. They didn't accuse their slaves of crimes or incompetence and hound them with police and whips. They didn't make them scapegoats when things went wrong. Their hired slaves almost always worked in concert with white workers, and the commissioners didn't threaten skilled free workers by training slaves to replace them. That may leave some today with a bitter conviction that slaves were insulted because their skills were not recognized and employed, but it may have prevented a race riot in which whites attacked blacks.

If any slave in the city was miffed at not getting a chance to exhibit his skills, he soon got a small consolation. Evidence soon accumulated that some skilled white workers were not that good. In November, the private building housing the war department caught fire after a wake for a dead carpenter in the parlor next door. Bricklayers had made the party wall between the houses one brick thick and built the fireplace with "wood bricks."

The deficiencies of the bricklaying at the treasury building also soon became evident. The investigation of a fire there found wood bricks in the walls as well as logs stuffed in gaps left in the brickwork. When he began supervising the construction of the South Wing of the Capitol, Benjamin Latrobe inspected the North Wing and reported to President Jefferson that he thought some of the work criminally negligent, principally the brick work and roof. (Latrobe would soon have a devil of a time with the roof of the South Wing.) In 1808, his assistant John Lenthall was crushed to death as he tried to remove a poorly built brick arch just off the Senate Chamber.

Latrobe was not critical of all the work on the North Wing. He admired the stonework and hired the stonecutter George Blagden, who supervised most of it, to build the South Wing. It was Blagden who postponed moving unwanted stone off the Capitol Square in 1795 because he saw that the laborers who could do it were working so well tending the masons raising the Capitol walls. Laborers were needed to build the South Wing, and likely some were hired slaves.

Records kept on that building were not as detailed as those kept by the commissioners. The laborers used were as invisible to whites as those who built the North Wing with one striking exception. On October 17, 1807, before Latrobe let the House of Representatives move into its new chamber, he held the customary celebratory dinner for his workers. He invited 157 men, those still working and any men dismissed without cause. He neglected to invite any laborers, and in protest, his assistant Lenthall refused to attend.

Not extending the invitation to laborers probably kept the dinner an all-white affair. No researchers have found evidence of skilled slaves working on the South Wing, even though skilled slaves began to establish their presence in the city's workforce even in government employ. In 1795, the commissioners were shocked by the high wage James Clagett wanted for his slave Aaron, who repaired the commissioners' scow. In 1808, a slave named Aaron still owned by Clagett worked as a caulker at the navy yard where warships were built and repaired.

Yet judging by runaway ads, despite evidence that it was just like the rest of the South in its exploitation of African Americans, the city of Washington continued to attract runaway slaves. In October 1800, a Charles County slave owner advertised for the return of Nace, whom he suspected was hiding in Washington. Perhaps some slaves were under the impression that with the arrival of the federal government, Congress would exercise its power of exclusive jurisdiction over the District of Columbia to change the laws regulating slavery.

President John Adams had no slaves and hailed from a state where there could be no slaves. But as we showed in the introduction, when First Lady Abigail Adams saw twelve slaves removing dirt and rubbish from the White House grounds, she did not inquire as to how they might be freed even though they worked for men who worked for the president.

The inefficiency of that operation was her complaint, and not the only one. Her November 1800 letter that described the slaves went on:

> *You will be surprized to learn that in a country thus abounding with wood, we are in distress for want of it—at no price can cutters and carters be procured to supply the demands of the inhabitants—no provision was made previous to the coming of congress to supply them... The public offices have sent to Philadelphia for wagons and wood cutters.*

Not that Mrs. Adams blamed slaves or the commissioners for lack of firewood. She blamed the contractors with whom she and her servants had to deal:

In November 1800, First Lady Abigail Adams described hired slaves removing dirt and rubbish from the White House yard. *From the Library of Congress.*

The lower class of whites are a grade below the negroes in point of intelligence and ten below them in point of civility. They look like the refuse of human nature; the universal character of the inhabitants is want of punctuality, fair promises—but he who expects performance will assuredly be disappointed.

Of course, the slaves Mrs. Adams saw working were not yearly hires from St. Mary's and Charles Counties. That was the old system. Shortly

155

after ending that system, the commissioners realized they had gone too far and began hiring slaves on a piecemeal basis, for short terms and in small numbers compared to the old system. The new system became more or less the way the city used hired slaves until emancipation.

In 1800, at the first of the year, not the commissioners but their overseer, Samuel Smallwood, advertised for twenty-five laborers. He soon had eight because the commissioners loaned them for two days to the contractor building the war department building just west of the White House. Evidently none of Smallwood's hires could be spared to clean up the White House grounds. Commissioner Thornton offered to throw himself into the breach. "I have offered to do all in my power in laying out a garden and other conveniences," he wrote to Stoddert, "if my colleagues will only allow me two or three common laborers."

Stoddert didn't take a hint and didn't hire slaves on his account to give to Thornton. Stoddert badgered the commissioners to make the public squares and avenues presentable. His fellow merchants in Georgetown insisted on a paved footpath all the way from the bridge over Rock Creek to the Capitol, and that became Stoddert's chief concern. He asked the commissioners to find pavers in Baltimore. At that time, pavers in Maryland were primarily Irish, and there is no evidence that slaves did that skilled work.

In May, Smallwood placed an ad for eight men good at ditching, which must have been a comedown for a man who once supervised five times that many men. Shortly after placing that ad, Smallwood went to work at the navy yard, where he could place ads for thirty to forty men.

The commissioners also availed themselves of the growing number of free blacks in the city as well as slaves hiring themselves out who also made a few dollars off the commissioners. On January 17, 1801, the commissioners paid $5.33 to "Jasper Jackson's black people and other blacks." Previously, all their payment for hired slaves had gone directly to the masters. Jasper Jackson, who lived in Georgetown, had made $52.50 for quarterly hire of slaves in 1798 and 1799. In 1800, it seems his slaves and their friends got work on their own.

Of course, $5.33 is not a big payday. Nor was the $5.60 some slaves got in extra wages to saw soapstone, nor the $0.67 the commissioners paid Rhody Butler in April 1801. But more money getting into the pockets of African Americans, enslaved and free, began to build the Washington community.

Stopping the slave hire system didn't stop the slow but steady growth of Washington's African American population. In 1803, the city counted itself

again. There were 338 male slaves and 103 free black males; 379 female slaves and 120 free. Since 1790, the number of blacks had more or less doubled. Of course, in that time the number of whites had soared from a few plantation families to enough to fill a village if not a city. There were 3,412 whites. The census made a point of trying to prove that Washington was an industrious city, estimating that there were 400 men in the building trades. That hefty number probably included only whites.

But there was always rubbish to pick up. Judging from the records, the commissioners first addressed the problem on the Capitol Square. There a Captain Coyle was filling Captain Elisha Williams's shoes by overseeing the overseers, in this case, just one overseer. Smallwood's first replacement didn't last long. Captain Coyle needed a new one, and the commissioners hired a Mr. Tippett who they hoped would do. In September, they warned Coyle, "It will be absolutely necessary that some industrious active man should be employed to push on the work" and ordered him "to increase the number of laborers to twenty and the Carts to eight or ten at least."

On November 11, a few days before the first lady arrived and two weeks before she wrote her letter quoted previously, the commissioners wrote to Stoddert that they would have "an Overseer and twenty good Laborers" available to clean up the White House yard in "a few days."

Probably after they spruced up the Capitol Square, Tippett and a dozen slaves moved on to the President's Square, where Mrs. Adams concluded "two of our hardy N. England men would do as much work in a day as the whole 12."

She should have been there when the sawpits were singing and lived the story of the White House as many slaves had. They could have told her some things.

So let's hoist the sails on our imaginary sloop again. Although we have no idea what the hired slaves did after they were disbanded, we can hope they returned to families, snug cabins and vegetables. Let's suppose that Master Plowden has business in Washington and asks Moses if he wants to take a break from Resurrection Manor and see the buildings he worked on. That imagined, let's be clear, there is absolutely no record of a slave walking into the White House and asking to see anything inside, let alone getting up on the roof, which many slaves were more intimately acquainted with than any men alive.

What if Moses sails up on the imaginary sloop in the fall of 1814 and then goes to the huge building on the west side of the city, still the largest home in the country, though temporarily vacant. Moses knows about the

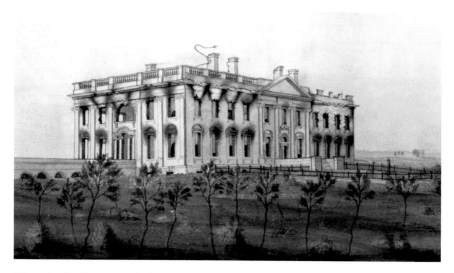

When the British burned the White House in 1814, all the work of slave sawyers was destroyed. The stones other slaves hoisted up onto the walls remained. *Crop of a painting by George Munger, now in the White House, from Wikimedia Commons.*

War of 1812. The British soldiers who had recently burned the building had fought near and sailed below Resurrection Manor. (Obviously, as we imagine Moses, he didn't join the St. Mary's County slaves who responded to the British offer of freedom if they ran away and joined the British. Judging from records collected by the Maryland Archives, at least eighty-four did.)

If Moses walks over where his old sawpit was, now level ground, and peeks inside the building, he'll see that all the woodwork has been destroyed, all the boards he sawed, all the timbers and rafters burned. If Moses is a religious man, well knowing all the unrewarded work that had gone into that building, he might say it was the Lord's judgment.

Then, what if Plowden, who made a few hundred dollars hiring out Moses, is at his side and asks, "Moses, Hoban is getting up a crew to rebuild it. Shall I sign you up?"

You decide how Moses would have answered.

LISTS OF MASTERS, THEIR SLAVES
AND FREE WORKERS

The commissioners never had a list compiled of all the slaves they hired, nor is there a list of their masters. Immediately below are partial lists of hired slaves whose masters are noted on payrolls and receipts in the commissioners' records that I've seen. The list is alphabetized by the last name of the master. There follows a list of masters paid for slave hire, but the names of their slaves are not known. Then there follow lists of free black laborers and white laborers taken from payrolls. Finally, there are partial lists of skilled workers.

MASTERS AND THEIR SLAVES

Mr. Alexander: Dick, Jim, Richard
Bennett W. Barber: Richard and at least three other slaves
William D. Beall: Davy, Frank, Newton
Joseph Beck: Ignatius
Middleton Belt: David, Dick, George, Jack, Jacob, John, Nero, Peter
James H. Blake: Abraham, James, Joseph, Isaac, William
Thomas Bond: Harry, James, Ned
Edward Boone: George, Robert, Stephen
Ignatius Boone: Charles, Jacob, Jacob, Lewis, Moses
Captain J.T. Boucher: Bob, Dick

Eleanor Brent: Charles, David
Elizabeth Brent: Gabe, Henry
Jane Brent: Silvester
Mary Brent: Girard
Teresa Brent: Nace
James Broome: Benjamin, Edward, Jacob, Robert
Richard Brown: Basil, Jack, Jim, Liverpool
Henry Burch: Sam
James Burnes: Benjamin, Jack, William
Benjamin Burrough: Bob
Edward Burrows: Josias, Thomas
Overton Carr: Nathaniel, Stephen
William Cartwright: Bob, Charles
Gerrard Causin: George
Alexander Chisley: Dick, Mich, Nace
James Clagett: George
John Cleare: Charles, Stephen
Clemonds: Henry
Joseph Dant: Stephen
Nathaniel Dare: John
John Davidson: George
Miss Anne Digges: Dick, Jack, Tom
Thomas Dixon: Will
Robert Douglass: Adam, Cato, Sam
Burton Ennis: Catherine Green
Bennett Fenwick: Harry, Joe, John, Luke, Tom
George Fenwick: Jacob, Orston
Joseph Forrest: Charles
Goldsmith: Charles, Harry, Nace
James B. Heard: Peter
James Hollingshead: Abram, Benjamin, Charles, Osten
Hoover: Solomon
Jasper M. Jackson: Francis, James, Josiah, Pompey
John Jackson: Oliver
Susannah Johnson: Basil, Isaac, Nace, Peter, Will
King: Jarrott
John Linton: Jack
John Lynch: Joe
Mary Magruder: George, Oliver

Luke F. Matthews: Davy, George
Miss McGruder: Dick
E.J. Millard: Joe, Tom
Susannah Mills: Clinton, Jerry
Neale: Jerry
Clement Newton: Joseph, Nace, Ralph
Bernard O'Neill: Bob, Gus, Harry and one other slave
Hezekiah Orme: Miles
Owens: Peter
Parker: George, Isaac, Nace, Robert
William Pearce: Jack
Edmund Plowden: Arnold, Bob, Gerard, Jack, Jess, Jim, Jim, Lin, Moses, Tony
John Porter: Moses
Joseph Queen: Anthony, Joseph, Moses, Tom, Walter
Reed: Bard
Anthony Reintzell: Amos, Charles, Dick, Jacob, Will
Valentine Reintzell: George, Mike
Alexander Scott: Emanuel
Gustavus Scott: Bob, Kit
Jane Scott: Thomas Humphrey
Olley Scott: Manuel
Peter Short: Anthony
Edward Simmes: Moses, Sam, Will
Mary Simmes: Will
James Simpson: Henly, John, Robert
Samuel Smallwood: Daniel, Davenport, Edward, Henry, Randall, Robert,
 Stephen, William
James Stone: Jacob, Salisbury, Tony
Louis Stone: John
Elizabeth Thomas: Fielder, William
Toney: Jacob, Thomas
Joseph Turner: Alexander, Ben
Venable: Charles, Moses
Wilson: Abraham, Dave
Francis Wolfe: Jack
Leonard Wood: Thomas
Robert Young: Abraham, Jacob, Sandy

MASTERS BUT SLAVES' NAMES NOT KNOWN

J. Adderson
Ann Barber
Luke Barber
Richard Beck
Sarah Bond
Samuel Briscoe
Hammett Brookes
Catherine Brown
William Bryan
Richard Bryon
Jacob Butler
William Cartwright
Margaret Chew
William Deakins
James R. Dermott
William Digges
William M. Duncanson
Catherine Graves
Francis Hammersley
James Height
James Hoban
Thomas Hodges
Gladen Hunt

Joseph Ireland
Joseph Jackson
Richard Kent
James Key
James Latimer
Thomas Law
Charles Love
William B. Magruder
Luke F. Matthews
William Mills
Thomas Parran
Zephaniah Prather
Michael Reiley
Clemont Sewell
Joseph Simmes
William Somerville
Benjamin Sunderland
John Syle
Charles Tarlton
William Thornton
Caleb Varnal
Nathan Walker
Thomas Wolfe

FREE BLACK LABORERS

Isaac Butler
Jacob Butler
Rhody Butler

Free Caesar
Jerry Holland

FREE LABORERS LIKELY WHITE

Richard Bannister
George Bartley
William Bartley

Henry Bateman
William Bateman
James Blois

Jonathan Blois
John B. Booth
John Bradmen
Sandy Breant
Josias Breeden
Thomas Bren
Charles Brown
Robert Brown
Enoch Bryan
Thomas Burnett
Tom Butler
Haze Butt
Thomas Caffray
Joseph Callender
Ignatius Carroll
Gabriel Coal
John Colloco
John Cook
Michael Crane
James Crooks
Horatio Cross
James Cross
Thomas Cross
Charles Cusick
George Cusick
Lasor Dalton
John Dent
Jere Devereux
John H. Dickson
Thomas Dixon
John D. Doran Sr.
John Doran Jr.
Richard Dorin
Robert Drury
Robert Edwards
Joseph Ellis
Philip Ellis
Joseph Essex

Albin Fenwick
Gerrard Gibson
Reubin Gibson
John Gray
John Greene
Albin Hardman
Tobias Hawkins
Richard Hazel
Gustavus Higdon
John Hilton
Jesse Howard
Joseph Howard
John Ivens
Joseph Jarber
Joseph Johnson
William Keating
Anthony Kennedy
Thomas King
John Leatch
Covington Lewis
Josiah Long
William Long
George Love
Enoch Lovely
Albin Luxore
Henry Mahew
Thomas Mason
Francis Mattingly
Ralph Merton
Ambrose Moriarty
Jacob Morris
John Murray
Peter Neale
Francis Nebit
Bernard Parsons
Joseph Parsons
Benjamin Pears
George Pepper

Heze Powell
James Powell
Joseph Rock
George Ross
Philip Russell
Jacob Sampson
Philip Savoy
James Sheridan
Jane Short, cook
Peter Short
Stephen Simms
Francis Smith
James Smith
Thomas Smith, cook
Walter Smith
William Smith
Henry Spalding

Edward Speak
William Stewart
Rezin Talbert
Notley Thomas
Aleck Thompson
Dyson Tippet
John Truax
Caleb Wade
James Walnutt
William Wellmon
William Wheatley
Jesse White
Jesse Williams
Walter Williams
Joshua Wilson
Dick Wise
George Wise

OVERSEERS

Thomas Hardman
James H. Hollingshead
George Johnston
Bennett Mudd
Isaac Naismith

Samuel Orme
John S. Slye
Samuel N. Smallwood
Tippett
William White

SAWYERS

Alick
Anthony
Billy
Charles
Clem
David
Dick
George
Harry

Huier
James
Jerry
Jess
Jim
Lin
Moses (Moses)
Moses (Plowden)
Oliver

Perry
Sam
Sill

Stephen
Thomas

SLAVE CARPENTERS

Ben (Hoban)
Daniel (Hoban)
Harry (Hoban)
Peter (Hoban)

James (Purcell)
Tom (Purcell)
Tony (Purcell)

FREE CARPENTERS

John Anderson
John Atkins
James C. Aull
Robert Aull
Charles Bagelieu
Edward Ball
Walter Barron
Thomas Barry
Hezekiah Berry
Nicholson Bevins
Clem Boswell
John Brown
Wilson Bryan
Walter Butler
Daniel Caffrey
Henry Charters
Samuel Clokey
James Coughlan
Patrick Curry
Samuel Curtis
John Dickey
Thomas Dickey
Michael Dowling
James Duncan
Alexander Edelen

Andrew Farm
Sam Fowler
John Galvan
Phill Garlic
Robert Gibbons
James Graham
William Hanson
John Harwood
George Haubert
Patrick Healy
Joseph Hoban
Robert Howard
Moses Hurly
Hugh Jackall
David Johnson
William Johnson
James Johnston
Anthony Jones
Peter Joyce
Thomas Kean
Wm Kief
William Knowles
John Lennox
Peter Lenox
Thomas Little

Floyd Logan
Randolph Logan
Charles McColly
John McCorkill
Samuel McCorkill
George McCormick
William McGill
James McGurk
Thomas McMinon
Clement McWilliams
William Means
Walter Miles
John Minor
Henry Minsuer
George Moor
Michael Moor
John Nixon
Stephen Norris
Robert Oliver
Nathan Orme
James Parsons
Walter Pearson
Jos Philips
Phillip Phillips
Peirce Purcell
Redmond Purcell
John Rea
John Regan

John Reid
Thomas Right
William Robertson
Robert Rose
George Sandford
Thomas Sandiford
Hugh Satchell
Alexander Shaw
Timothy Sheedy
William Simms
Leven Smallwood
Clotworthy Stephenson
Robert Sutton
James Thompson
John Thompson
Andrew Thomson
George Thomson
S. Tompkins
Simon Toole
John Walker
Nathan Walker
William Warrington
James Watkins
Thomas Webster
Rich White
Clement Williamson
Robert Wilson
Samuel Wright

STONE WORKERS

Thomas Allen
Thom. Barth
William Beard
John Bennett
George Blagden
William Bond
Peter Brady

Francis Brown
Archibald Burnes
John Cochran
Joseph Cockran
Bernard Crooke
David Cumming
Thos. Dollar

Thomas Doran
James Dougherty
John Douglas
Henry Edwards
J. Gallagher
Frederick Gibson
Samuel Godfrey
James Gowens
Robert Graham
James Henry
John Henry
John Hill
Joseph Huddleston
James Jack
George Jacob
David Kay
Peter Larimore
James Maddin
Patrick McCarty
Jonathan McDonnough
James McIntosh
William McIntosh
Neal McKeever

Nathaniel Mcleish
Frederick Necks
David Ogilvie
Robert Oliver
James Paxton
Pew
Alexander Reid
James Reid
Alexander Robertson
John Shaw
Andrew Shields
Andrew Shulls
William Simpson
Hugh Somerville
James Somerville
William Symington
Robert Tolmie
Robert Vincent
David Waterston
James White
Alexander Williamson
John Williamson
Alexander Wilson

BRICKLAYERS

Robert Brown
Thomas Dealy
William Eves
Patrick Farrell
James Green
Tim Hogan
John Lipscomb
James Maitland
Thomas Mitchim

John Pelis
James Stephenson
Francis Thomson
William Whitehead
George Wilkinson
Young Wilkinson
Negro William (Stephenson)
Allen Wyley

SOURCES

The commissioners' records are primarily held by the National Archives in Records Group 42. The commissioners' proceedings include their resolutions and orders. There were no minutes kept of their board meeting, but a fuller picture of the thinking behind their actions is found in the copies of their letters sent. Both the proceedings and letters sent are available on microfilm. Their letters received are original letters, and they, too, are on microfilm. The commissioners did not require timely reports from superintendents and overseers, but there are several reports on file. All three collections are arranged chronologically, and there are indexes of correspondents also microfilmed.

Many of the documents from the proceedings and letters sent have found their way into other collections. Most documents dealing with surveying and waterfront are in an 1898 book titled *United States v. Martin F. Morris, et al. Record in the Supreme Court of the District of Columbia (the Potomac flats Case)*. The letters the commissioners sent to the president and secretary of state are in the collected papers of George Washington and Thomas Jefferson. The commissioners' letters to them were long, informative and all online. The easiest access to their letters is the National Archives Founders Online website.

The rest of the commissioners' records are not online and have to be accessed at the National Archives. Most of those records are in Record Group 42, to which there is a good guide: Records of the Office of Public Buildings and Public Parks of the National Capital Record Group 42,

compiled by Jane M. Dowd, 1992. These records include ledgers, daybooks, contracts and receipted accounts.

The records that bring us close to the daily lives of the hired slaves and other workers are the payrolls and time sheets kept by the commissioners. These are not in Record Group 42. They are also not mentioned in any of the guides to the many record groups into which the Archives organizes all their records. Most of those guides were written since I had access to those records in 1989 when I noted them as being in both Record Groups 39 and 217. Payrolls that the Archives has put online are cited as being in RG217.

Several of the payrolls and other records showing the names of hired slaves are currently online at the United States Capitol Historical Society web page.

Examining the commissioners' records will introduce you to the many problems faced by the commissioners. At the time, hiring slaves wasn't one of their problematic policies, so there is relatively little about the hired slaves in their records.

GENEALOGICAL RECORDS

The only leads about hired slaves' lives that one can glean from the commissioners' record are the names of their masters. Census data, other information shared online by genealogists and information records pulled together by the Maryland Archives online can help place the slave's home and provide more information about his master.

MANUSCRIPT SOURCES

Georgetown University Special Collections Research Center

Maryland Province Archives of the Society of Jesus

Library of Congress

Samuel Davidson letter book and ledger
Nicholas King Papers

Sources

Thomas Law Papers
Robert Morris letter book
Walter Stewart Papers
William Thornton Papers
George Washington Papers

Historical Society of Pennsylvania

James Greenleaf Papers
John Nicholson letter books

Historical Museum of Pennsylvania

John Nicholson correspondence

Massachusetts Historical Society

Adams Family Papers
William Cranch Papers

Maryland Archives

Slavery Commission of the Maryland Archives online: http://aomol.msa.
maryland.gov/html/commission.html

Newspapers

Georgetown Centinel of Liberty
Georgetown Weekly Ledger
Maryland Journal
National Intelligencer
Virginia Gazette
Washington Federalist
Washington Gazette
Washington Impartial Observer

Published Sources

Abbott, W.W. *The Papers of George Washington*. Charlottesville: University of Virginia Press, 1987–present.

Allen, William C. *History of Slave Laborers in the Construction of the Capitol*. Washington, D.C.: Government Printing Office, 2005.

———. *History of the United States Capitol: A Chronicle of Design, Construction and Politics*. Washington, D.C.: Government Printing Office, 2001.

Arnebeck, Bob. *Through a Fiery Trial: Building Washington 1790–1800*. Lanham, MD: Madison Books, 1991.

Bacon-Foster, Cora. *Early Chapters in the Development of the Potomac Route to the West*. Washington, D.C.: Columbia Historical Society, 1912.

Baker, Abby Gunn. "The Erection of the White House." Records of the Columbia Historical Society, vol. 16, 1913.

Bedini, Silvio A. "The Survey of the Federal Territory: Andrew Ellicott and Benjamin Banneker." *Washington History* 3, no. 1 (1991).

Berg, Scott W. *Grand Avenues: The Story of Pierre Charles L'Enfant, the French Visionary Who Designed Washington, D.C.* New York: Vintage Press, 2008.

Bordewich, Fergus M. *Washington: The Making of the American Capital*. New York: Amistad, 2008.

Bowling, Kenneth. *Peter Charles L'Enfant: Vision, Honor and Male Friendship in the Early American Republic*. Washington, D.C.: Friends of the George Washington University Library, 2002.

Brown, Glenn. *History of the United States Capitol*. 56th Cong., 1st sess., 1902. S. Doc. 60.

Bryan, Wilhelmus B. *A History of the National Capital*. New York: Macmillan, 1914.

Caemmemer, H. Paul. *The Life of Pierre Charles L'Enfant.* Washington, D.C.: National Republic Publishing Company, 1950.

Chase, Philander D., ed. *Papers of George Washington.* Charlottesville: University Press of Virginia, 2002.

Cornell University ILR School. "Trade Agreement Between Building Contractors Association, Inc. and Mason Tenders Labor Council of Greater New York." http://digitalcommons.ilr.cornell.edu/cgi/viewcontent.cgi?article=1770&context=blscontracts.

Corrigan, Mary Beth. "Making the Most of an Opportunity: Slaves and the Catholic Church in Early Washington." *Washington History* 12, no. 1.

Dalzell, Robert F., Jr., and Lee Baldwin Dalzell. *George Washington's Mount Vernon: At Home in Revolutionary America.* New York: Oxford University Press, 1998.

Delaplaine, Edward S. *The Life of Thomas Johnson: Member of the Continental Congress, First Governor of Maryland, and Associate Justice of the United States Supreme Court.* Westminster, MD: Willow Bend Books, 1927.

"Diary of Br. Joseph Mobberly." Maryland Province of Jesuits Papers, Georgetown University Special Projects. http://units.georgetown.edu/americanstudies/jpp/.

"Diary of Mrs. William Thornton." *Records of the Columbia Historical Society* 10 (1907).

Du Bois, W.E. Burghardt. *Black Reconstruction in America: An Essay Toward a History of the Part Which Black Folk Played in the Attempt to Reconstruct Democracy in America, 1860–1880.* Cleveland, OH: World Publishing Company, 1968.

Ellicott, Andrew. "A Letter from Mr. Andrew Ellicott to Robert Patterson, in Two Parts." *Transactions of the American Philosophical Society* 4 (1799): 49ff.

Feister, Lois M., and Joseph S. Sopko. (1996) "18th- and Early 19th-Century Brickmaking at the John Jay Homestead: The Process, Products, and Craftsmen." *Northeast Historical Archaeology* 25, no. 1. http://digitalcommons.buffalostate.edu/neha/vol25/iss1/6.

Ford, Emily. *Notes on the Life of Noah Webster*. New York: privately printed, 1912.

Gage, Mary, and James Gage. *The Art of Splitting Stone: Early Rock Quarrying Methods in Pre-Industrial New England 1630–1825*. Amesbury, MA: Powwow River Books, 2012.

Geiger, Mary Virginia. *Daniel Carroll*. Washington, D.C.: Catholic University Press of America, 1943.

Harris, C.M., ed. *Papers of William Thornton*. Vol. 1, 1781–1802. Charlottesville: University of Virginia Press, 1995.

Jefferson, Thomas. *Writings*. New York: Library of America, 1984.

Latrobe, Benjamin. *Correspondence and Miscellaneous Papers of Benjamin Henry Latrobe*. Edited by John Van Horne. New Haven, CT: Yale University Press, 1984.

LeeDecker, Charles, Lisa Kraus and Patti Kuhn. *Phase II Archaeological Investigation for the National Museum of African American History and Culture District of Columbia Final Report*. N.p.: National Capital Planning Commission, 2008.

Lusane, Clarence. *Blacks in the White House*. San Francisco: City Lights Books, 2013.

Maryland-National Capital Park and Planning Commission. *Prince George's County Planning Department, Ottery Group, Inc., Antebellum Plantations in Prince George's County, Maryland: A Historic Context and Research Guide*. N.p.: Maryland-National Capital Park and Planning Commission, 2009.

Mathews, Catherine van Cortlandt. *Andrew Ellicott, His Life and Letters*. New York: Grafton Press, 1908.

Mitchell, Stewart. *New Letters of Abigail Adams, 1788–1801*. Boston: Houghton-Mifflin, 1947.

Morgan, James Dudley. "Robert Brent, First Mayor of Washington City." *Records of the Columbia Historical Society* 3 (1899).

Neuwirth, Jessica L. "Archaeological Investigations at the Sotterley Plantation Slave Cabin St. Mary's County, Maryland." Sotterley Mansion Foundation, January 1996.

Niemcewicz, Julian. *Under Their Vine and Fig Tree: Travels Through America 1797–1799.* Edited by Meche Budka. Elizabeth, NJ: Grassman Publishing Co., 1965.

Padover, Saul K., ed. *Thomas Jefferson and the National Capital.* Washington, D.C.: Government Printing Office, 1946.

Pyne, W.H. *Picturesque Views of Rural Occupations in Early Nineteenth Century England.* New York: Dover Books, 1977.

Ridout, Orlando V. *Building the Octagon.* Washington, D.C.: American Institute of Architects Press, 1989.

Rochefoucauld-Liancourt, François-Alexander-Frederic. *Travels Through the United States of North America, the Country of the Iroquois and Upper Canada in the Years 1795, 1796, 1797.* London: R. Phillips, 1799.

Scott, Pamela. *Temple of Liberty: Building the Capitol for a New Nation.* New York: Oxford University Press, 1995.

Seale, William. *The President's House.* Vol. 1. Washington, D.C.: White House Historical Association, 1986.

Sessford, John. "Statistics of Washington." *Records of Columbia Historical Society* 11 (1908).

Sharp, John G. *History of the Washington Navy Yard Civilian Workforce, 1799–1962.* Naval District Washington, D.C.: Washington Navy Yard, 2005.

Snethen, Worthington G. *Black Code of the District of Columbia in Force September 1, 1848.* New York: Anti-Slavery Society, 1848.

Steffen, Charles G. *The Mechanics of Baltimore: Workers and Politics in the Age of the American Revolution.* Urbana: University of Illinois Press, 1984.

Twining, Thomas. *Travels in America 100 Years Ago*. New York: Harper Brothers, 1894.

United States Geological Survey. "Building Stones of our Nation's Capital." http://pubs.usgs.gov/gip/stones/index.html.

Warner, William W. *At Peace With All Their Neighbors: Catholics and Catholicism in the National Capital 1787–1860*. Washington, D. C.: Georgetown University Press, 1994.

Washington Times. "Trouble 116 Years Old Settled by Jury." May 5,1906.

"Writings of George Washington Relating to the National Capital." *Records of the Columbia Historical Society* 17 (1914).

INDEX

About the Author

B ob Arnebeck was born in Washington in 1947 and graduated from Montgomery Blair High School in 1965 and Beloit College in 1969. In 1970, his play *Watch the Fords Go By* was hailed by a Boston critic as a "fascinating failure." He returned to Washington and freelanced for the *Washington Post Magazine*. In 1987, he was a commentator on NPR's *Morning Edition*. He wrote *Proust's Last Beer: A History of Curious Demises* (Penguin Books, 1981) and *Through a Fiery Trail: Building Washington 1790–1800* (Madison Books, 1991). In 1994, he moved with his wife, Leslie Kuter, to Wellesley Island in the St. Lawrence River. In 2004, his "Encounters Between Otters and American Beavers" was published in the *IUCN Otter Specialist Group Bulletin*. Since 1999, he has explored American history on his web pages at bobarnebeck.com, sharing his research on Washington, D.C., as well as Dr. Benjamin Rush and the yellow fever epidemics of the 1790s. His son, Ottoleo, is an engineer specializing in microsensors.